Villager Jim's

Bobbin Robin

I would like to dedicate this book to my very special mum, who is in her eighties and fit as a fiddle. If I'm honest, she's actually more technical than I am, zooming off emails and text messages from her phone, sending me videos of her cats and photos of her garden blackbirds, mending her computer and fixing her printer. But of course the main reason I want to dedicate the book to my mum is the fact she made me the person I am. I will be forever grateful to her for the love and support she has shown me all my life, through good times and bad, and for being so equally caring towards me, my two brothers and our sister.

Thank you Mum for everything!

PS: Thank you also for always commenting on my images on my Facebook page and never saying a peep about who you are; it always makes me smile and want to respond with 'Thanks Mum'. I'm hoping this goes part way to shouting from the rooftops that you are the best mum in the world!

Villager Jim's

Bobbin Robin

WHITE OWL

First published in Great Britain in 2017 by
PEN & SWORD WHITE OWL
an imprint of
Pen & Sword Books Limited
47 Church Street
Barnsley
South Yorkshire
S70 2AS

ISBN 978 1 5267 0679 9

A CIP catalogue record for this book is available from the British Library.

Printed and bound in India by Replika Press Pvt. Ltd.

Pen & Sword Books Limited incorporates the imprints of Atlas,
Archaeology, Aviation, Discovery, Family History, Fiction, History, Maritime, Military, Military Classics, Politics,
Select, Transport, True Crime, Air World, Frontline Publishing, Leo Cooper, Remember When, Seaforth Publishing,
The Praetorian Press, Wharncliffe Local History, Wharncliffe Transport,
Wharncliffe True Crime and White Owl.

For a complete list of Pen & Sword titles please contact:
PEN & SWORD BOOKS LIMITED
47 Church Street, Barnsley, South Yorkshire, S70 2AS, United Kingdom
E-mail: enquiries@pen-and-sword.co.uk
Website: www.pen-and-sword.co.uk

Introduction

Venturing out with my camera to take photographs of the landscape and wildlife that surround my farm in the Derbyshire Peak District offers many rewards on a daily basis. One of the most delightful has been the relationships I have developed with individual birds and animals close to home, in my garden. It has been widely acknowledged that the robin is the nation's favourite bird, and in particular, the gardener's friend. This is because they tend to be much tamer and more inquisitive than other birds and will often sit on the proverbial spade handle looking for any feeding opportunity. But I think, above all, it is their sheer beauty and friendliness that makes them such a lovable garden bird.

We have three resident robins in our garden but Bobbin Robin is my favourite. I have had the pleasure of her company for the past three years, during which time I have witnessed her tirelessly bring up four clutches of chicks. She gives me great joy as she follows me around the garden. She even comes to sit on my bench with me for a chat – sometimes for over an hour! We have developed such a rapport: she knows me and I know her. For me, it is a chance to recharge my batteries and enjoy the enchantment of such a small creature being prepared to trust me

with her life. My reward for endless patience and perseverance – and a few mealworms – is a priceless window on the wonders of Nature.

Our garden is a haven for wildlife and Bobbin finds plenty of her favourite worms and insects there, depending on the season. I have to admit that I have helped her with a fair old number of mealworms, which I have delivered weekly, but of course that is entirely necessary when you have a queue of blackbirds, sparrows and chaffinches all lining up for their breakfast! I get through about 2 kilograms of mealworms a week, but I try to restrict feeding to only first thing in the morning and last thing in the evening, allowing all the birds to continue hunting for their natural food sources for many hours during the day. I am extra generous on freezing nights, when the smaller birds especially need extra energy during the night to survive.

In a typical day, Bobbin hops quite literally from pillar to post, always spending a few seconds looking around her as well as up to the sky to keep an eye out for sparrowhawks. She is often moving location but her activity is centred on a small outcrop of fir trees where she can quickly retreat to if danger should present itself. Part of her routine involves looking out for me; when she

spots me she comes very close and then bobs up and down and clucks, which is her way of saying 'give me some food this very second'! If she has young ones, she will always shoot off with the food. If it is not breeding season, she will go to a branch that offers some cover and feed herself. And then, with umpteen hops and skips, and pausing to check around for danger, she swoops back down to my bench to collect some more mealworms.

Of course, Bobbin's behaviour varies depending on the season. Winter is always harsh for garden birds and the extra help we can give them is crucial to keep up the numbers of local wild birds. This is the time to give them high energy foods such as sunflower hearts and mealworms. Summer is far less of a worry but I always find it is so nice to be able to help mums and dads bringing up their young. It is a pleasure to watch them take off with beaks full of seed or worms, knowing they are going to feed their tiny offspring, who are all fighting to survive.

Robins sing for most of the year round and their song changes in tone and length. In late summer, for example, when they are moulting, they tend to be quieter. At other times, they often sit on the edge of a branch and sing for long periods. Most people think that this is for a mate, but quite often it is their way of saying, 'This is my pad now; keep clear, or you're for it!' Bobbin, I have noticed, sings many times for pleasure too. She will often sit in silence with me and then turn and just start singing. I know she is not telling me to go away because she has voluntarily come to sit with me and appears to feel secure, so I can only dream of thinking that she is doing this just because she is happy for happiness's sake. I would wager anyone to come and sit with us for an hour and tell me otherwise.

The experiences I've shared with Bobbin and her friends are far too numerous to mention here. Just turn the pages to discover a mere fraction of those special moments I have captured with my camera.

Villager Jim

Visit Villager Jim's Facebook page at **www.facebook.com/villagerjim**
And his website at **www.villagerjim.com**

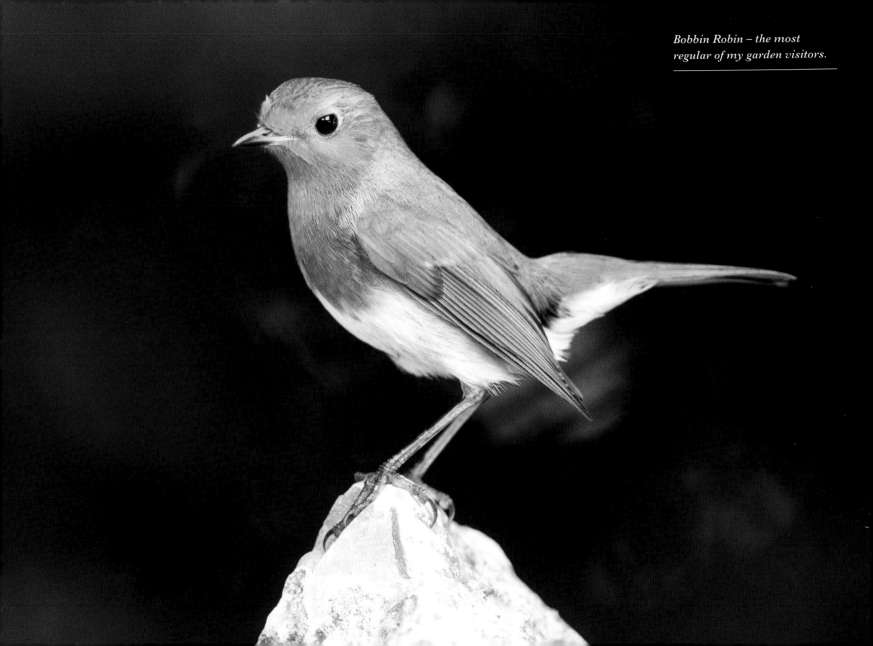

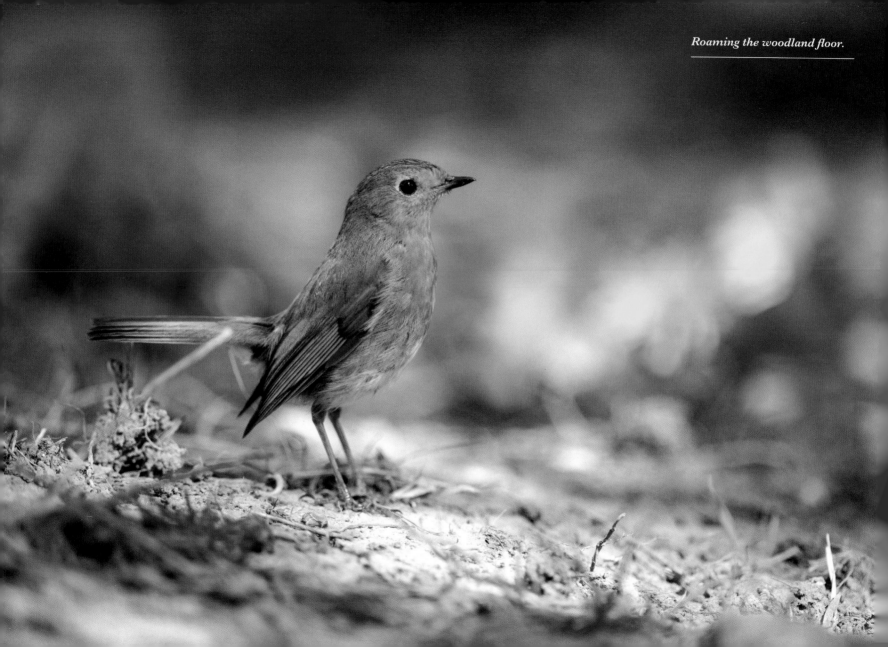

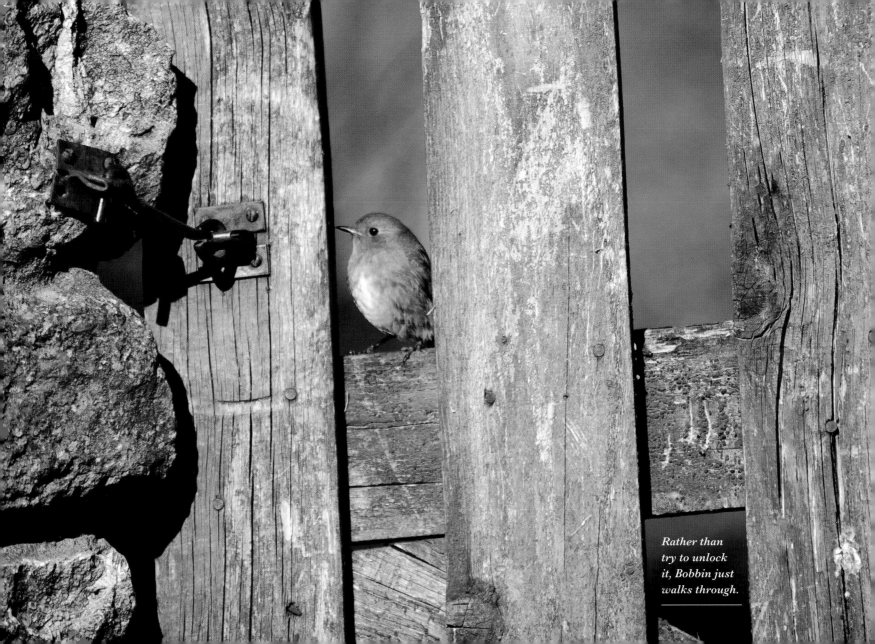

Rather than try to unlock it, Bobbin just walks through.

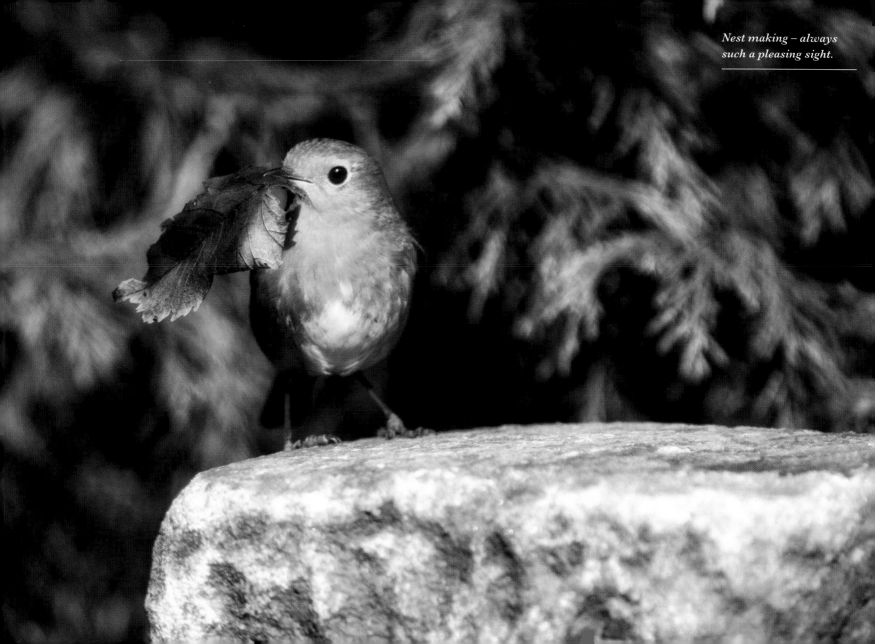

Nest making – always such a pleasing sight.

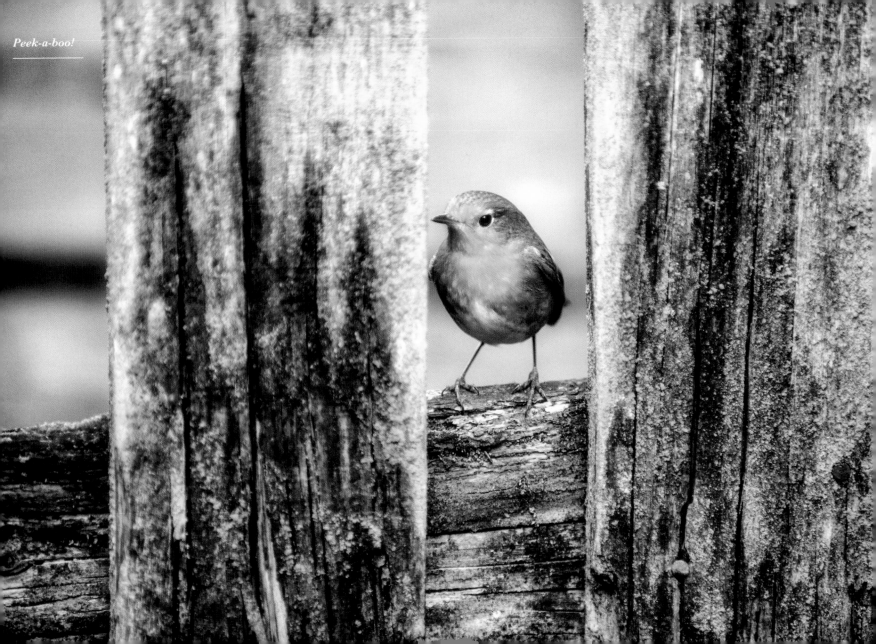

Peek-a-boo!

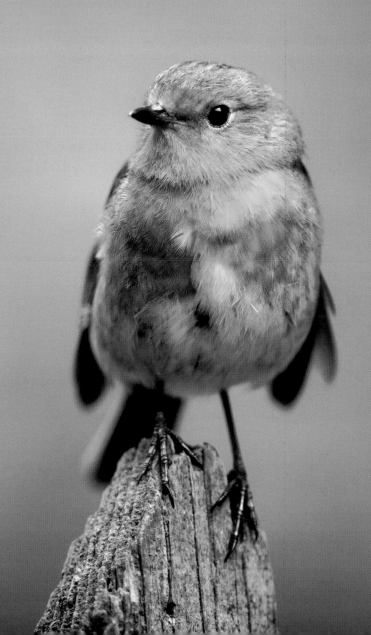

Sometimes I just sit and look at her and appreciate just how wonderful Nature is.

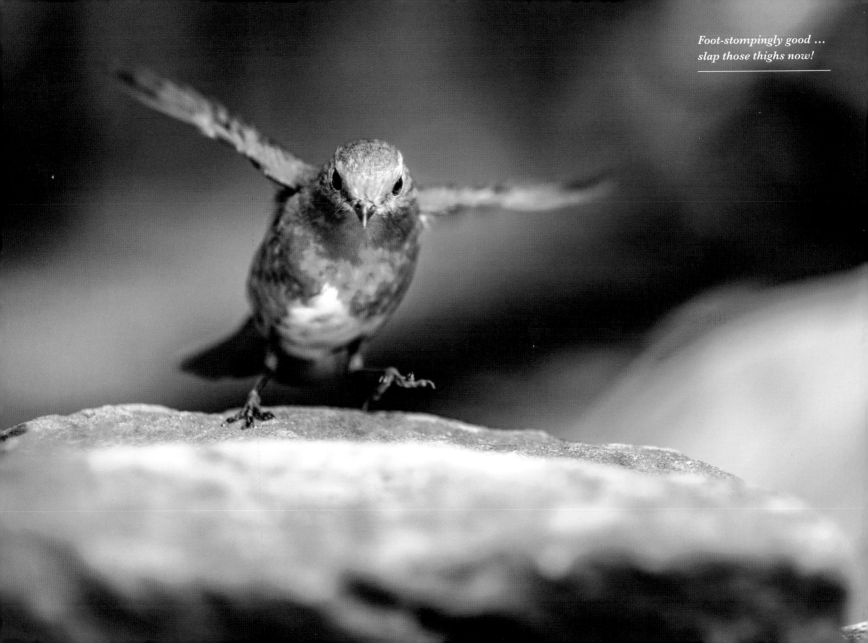

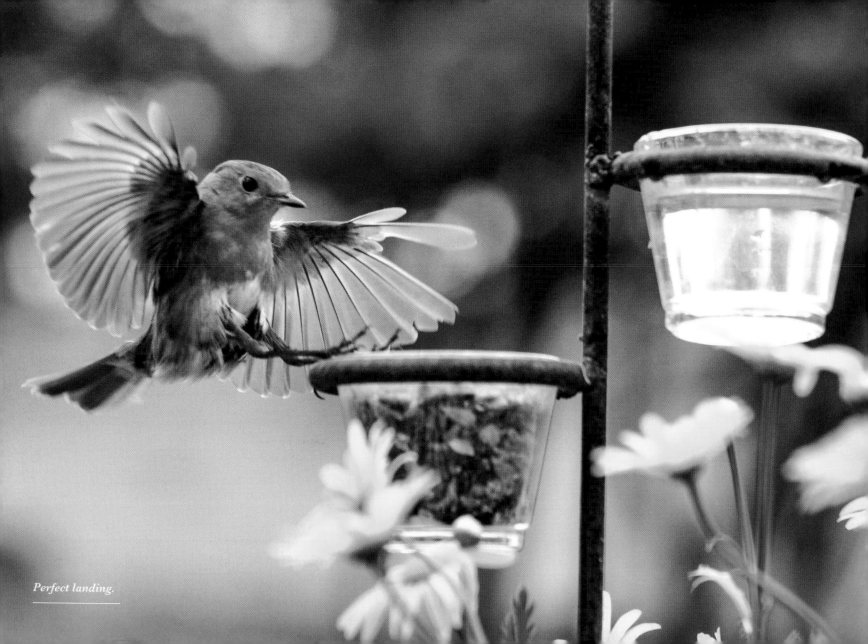

Perfect landing.

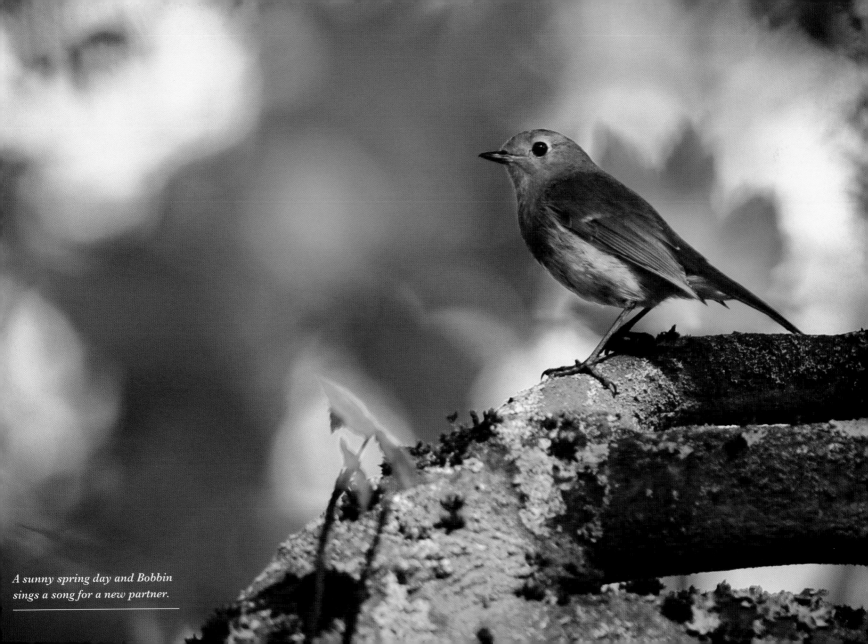

A sunny spring day and Bobbin sings a song for a new partner.

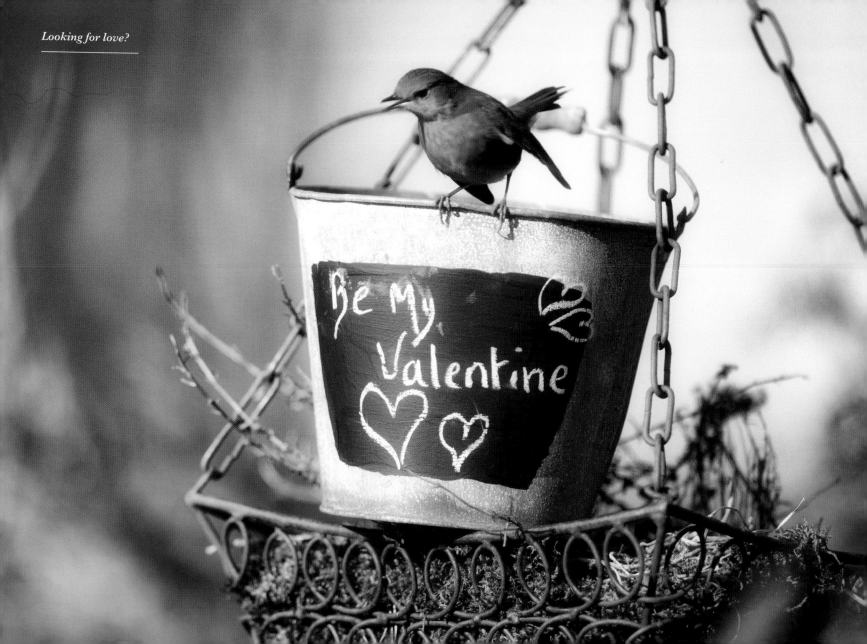

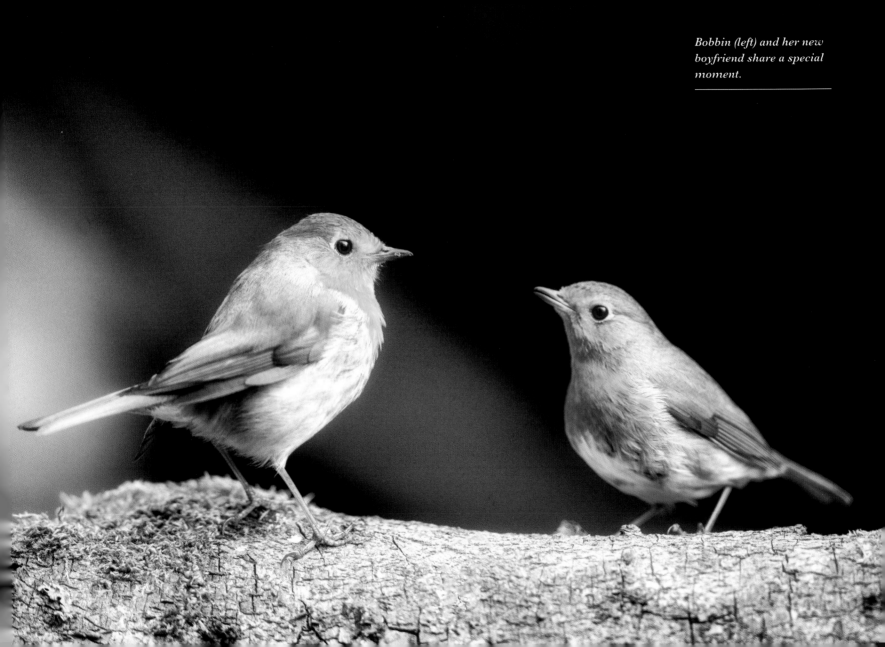

Bobbin (left) and her new boyfriend share a special moment.

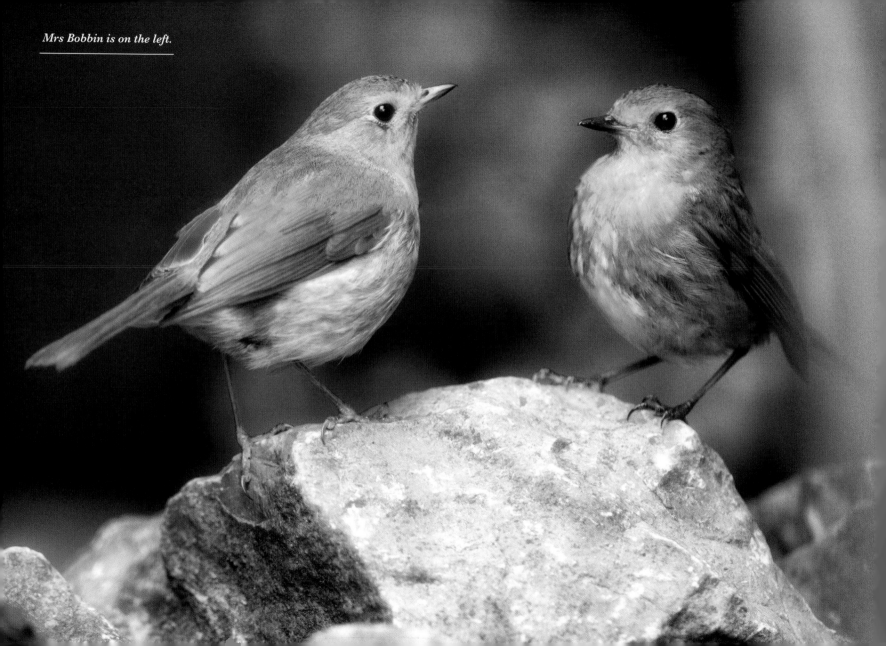

Mrs Bobbin is on the left.

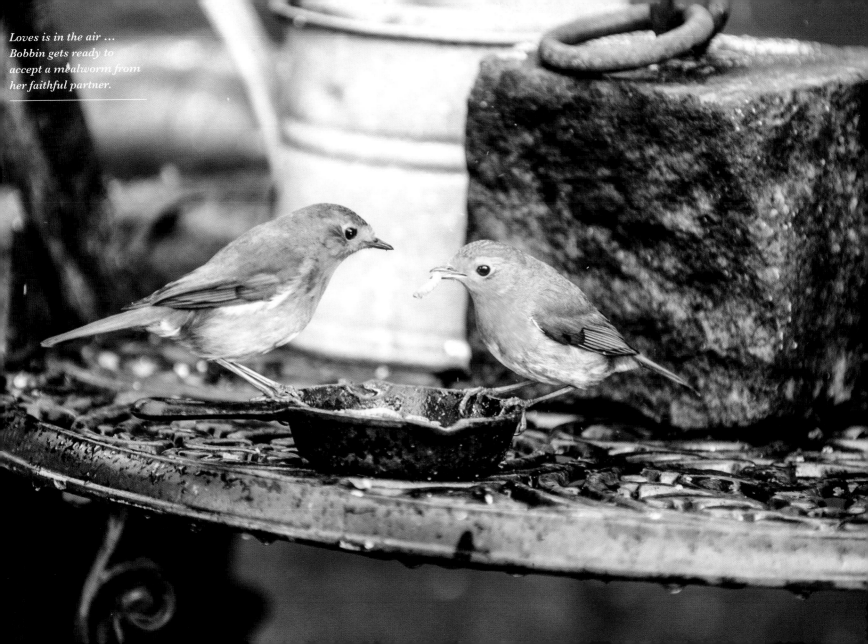

*Loves is in the air …
Bobbin gets ready to
accept a mealworm from
her faithful partner.*

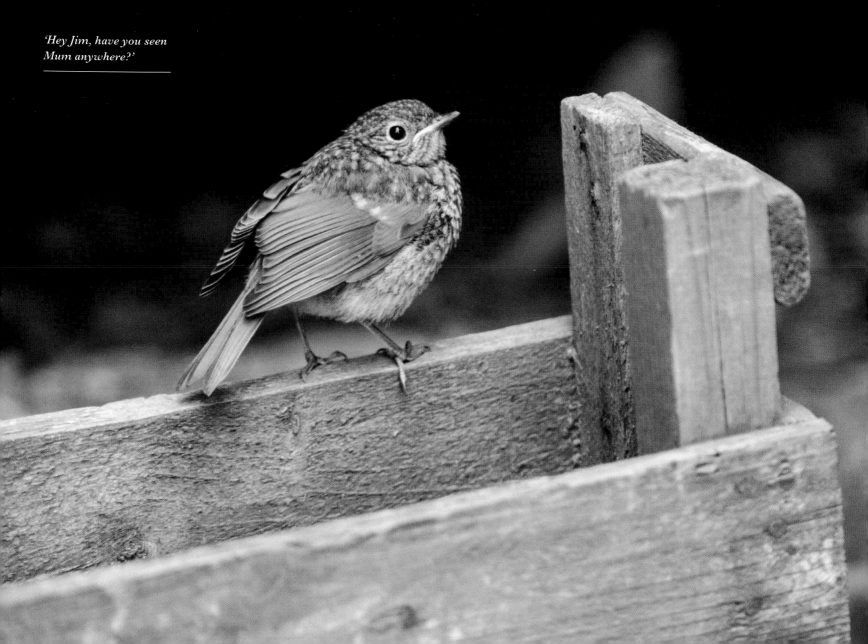

'Hey Jim, have you seen Mum anywhere?'

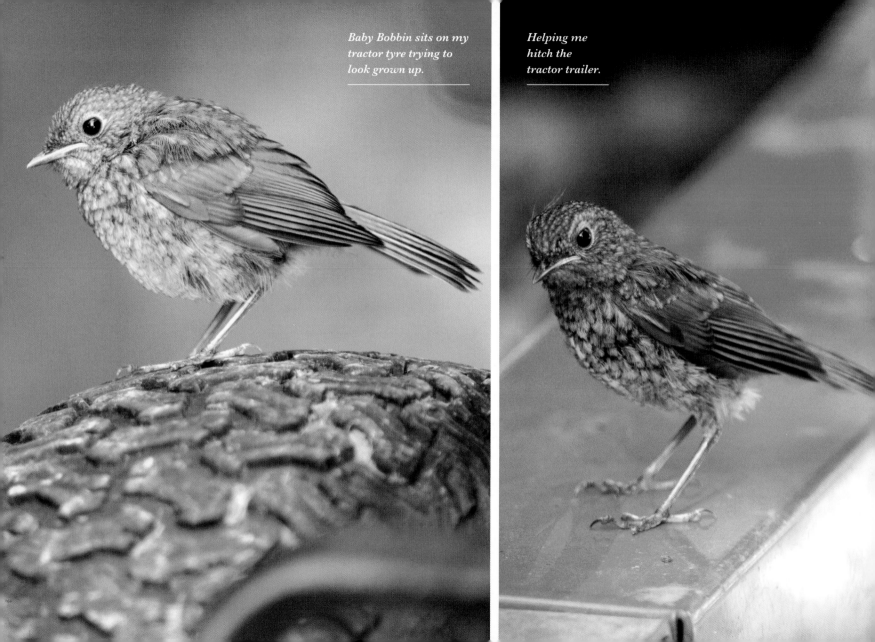

Baby Bobbin sits on my tractor tyre trying to look grown up.

Helping me hitch the tractor trailer.

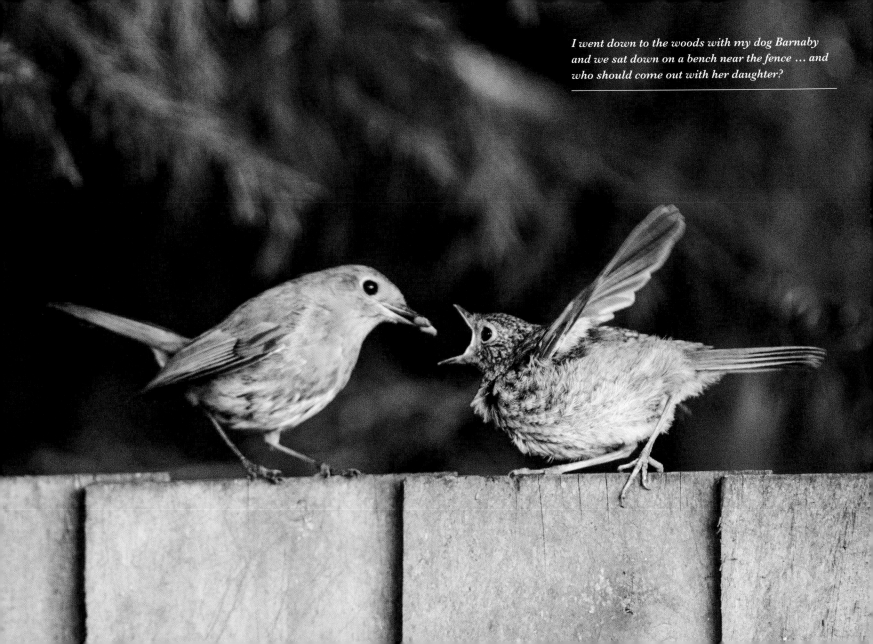

I went down to the woods with my dog Barnaby and we sat down on a bench near the fence ... and who should come out with her daughter?

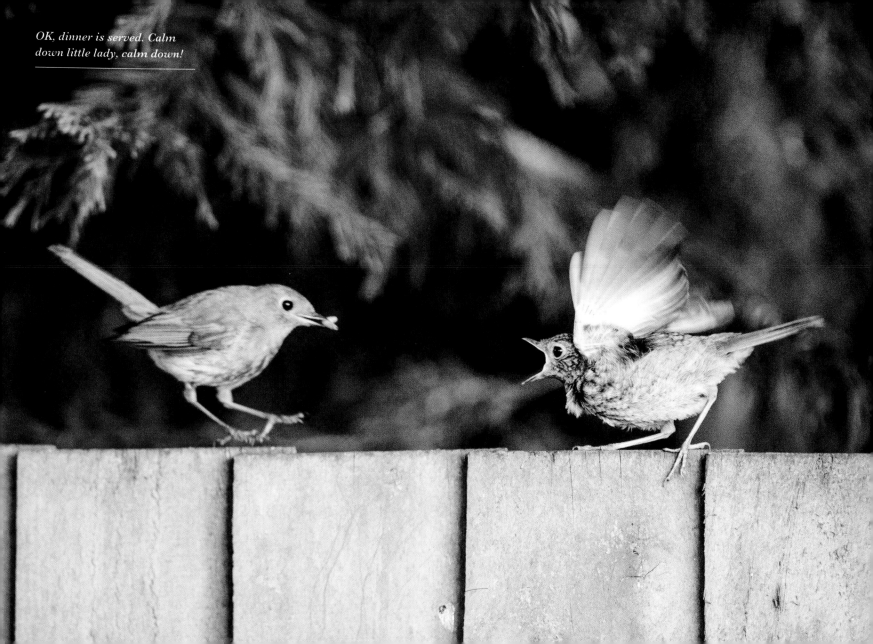

OK, dinner is served. Calm down little lady, calm down!

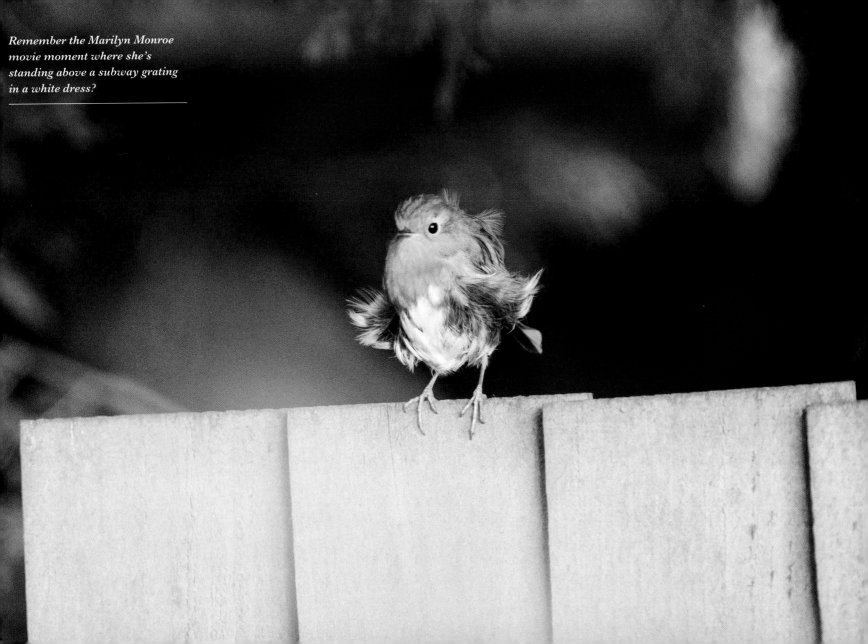

Remember the Marilyn Monroe movie moment where she's standing above a subway grating in a white dress?

Getting ready
for first flight.

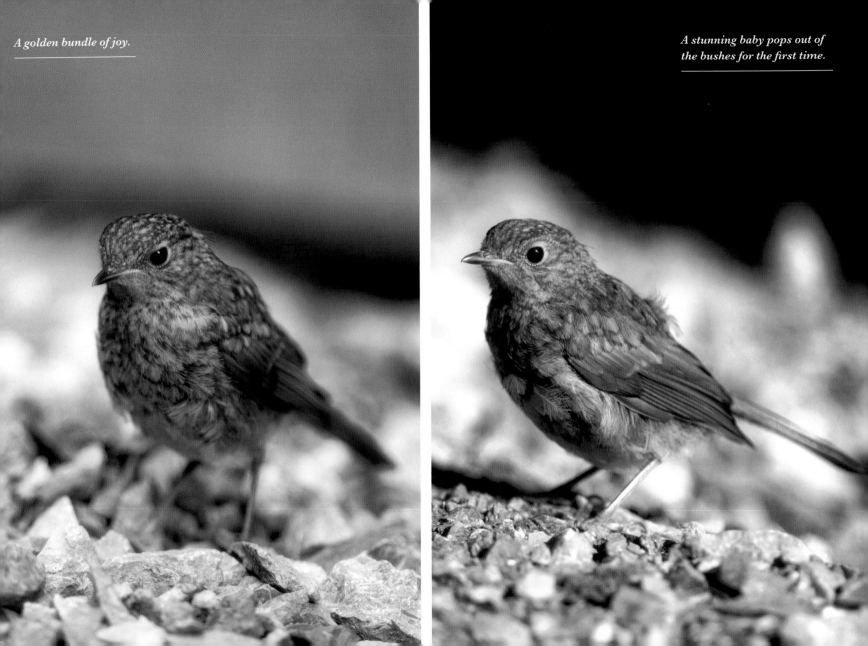

A golden bundle of joy.

*A stunning baby pops out of
the bushes for the first time.*

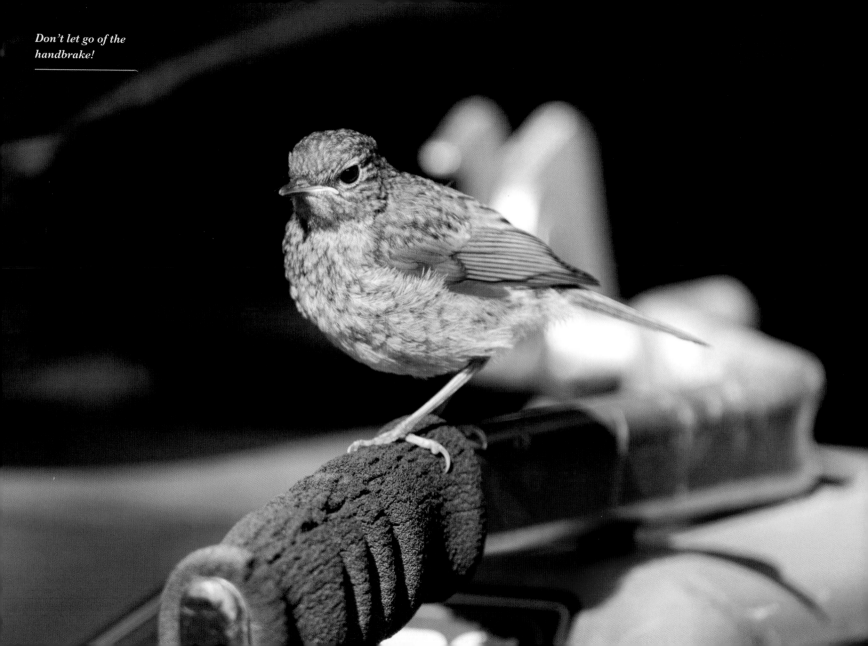

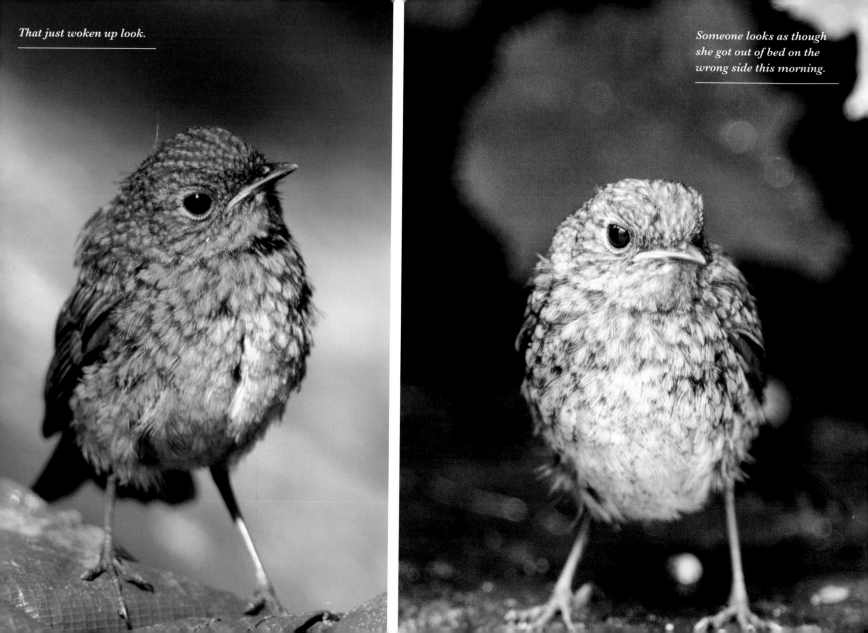

That just woken up look.

Someone looks as though she got out of bed on the wrong side this morning.

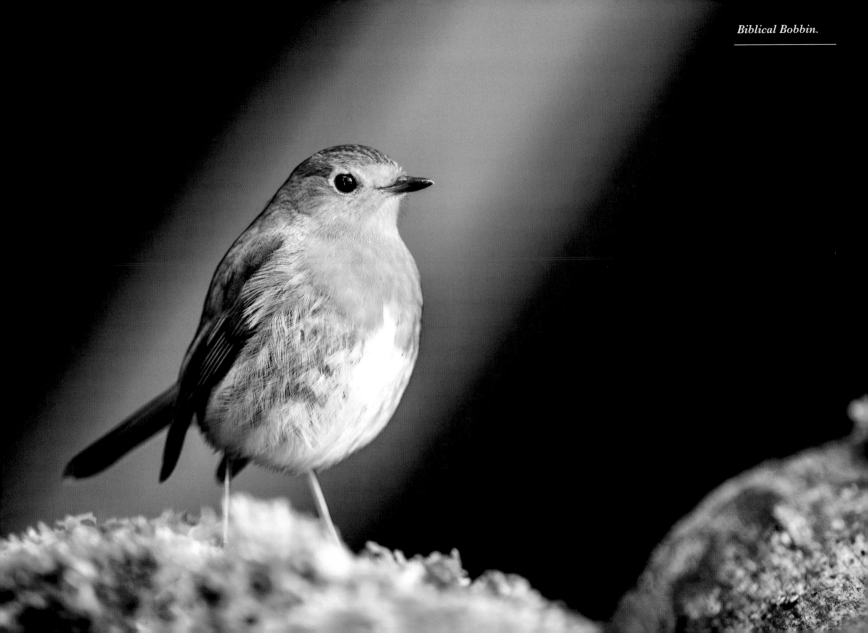

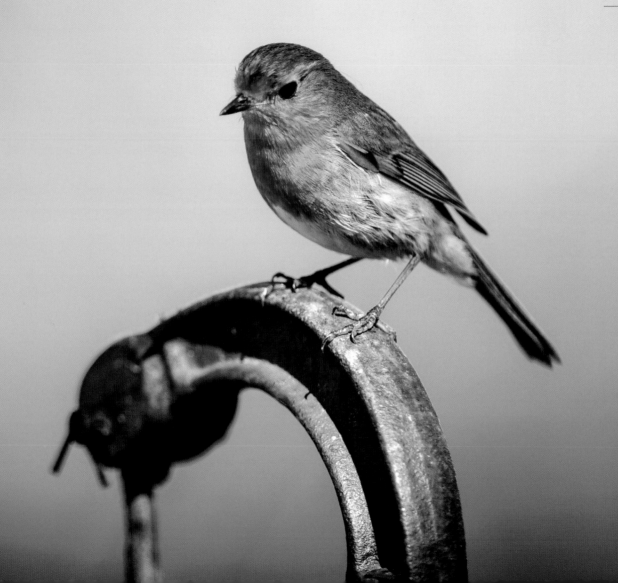

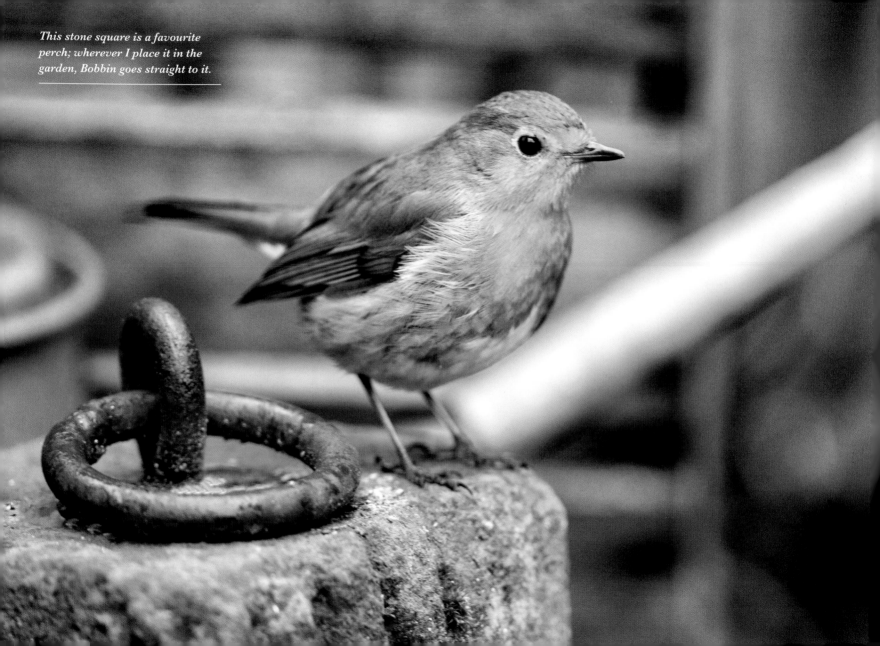

This stone square is a favourite perch; wherever I place it in the garden, Bobbin goes straight to it.

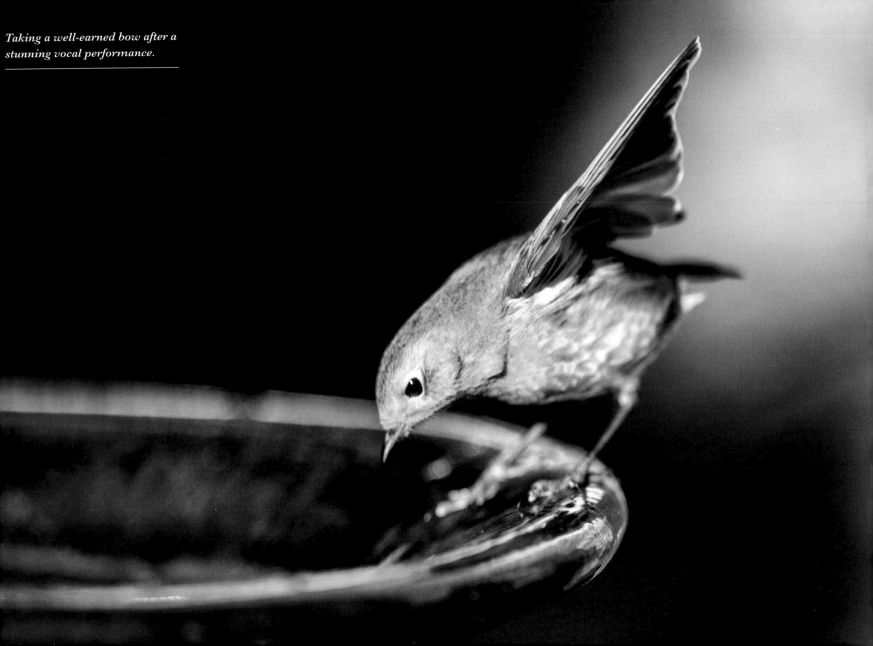

Taking a well-earned bow after a stunning vocal performance.

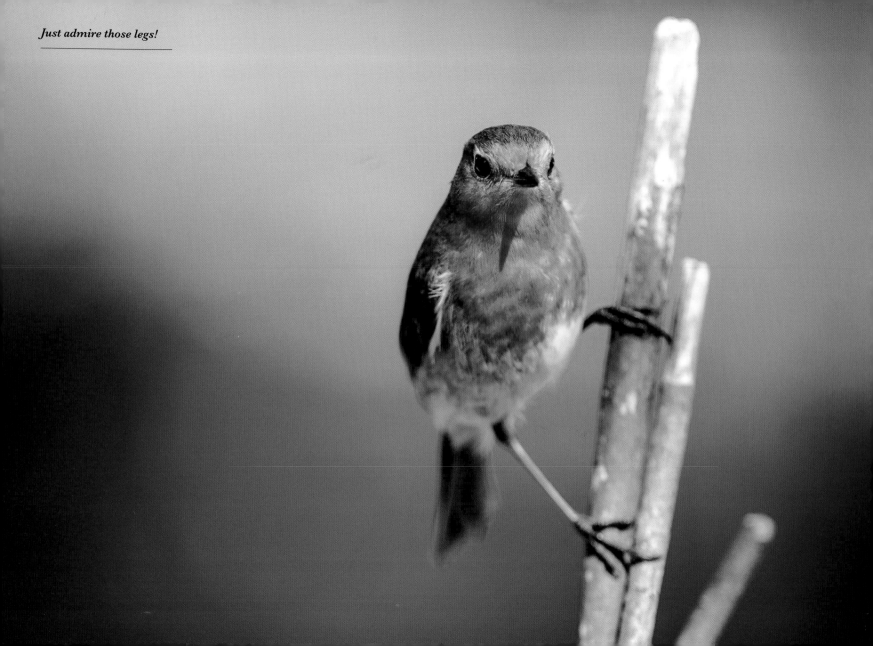

Just admire those legs!

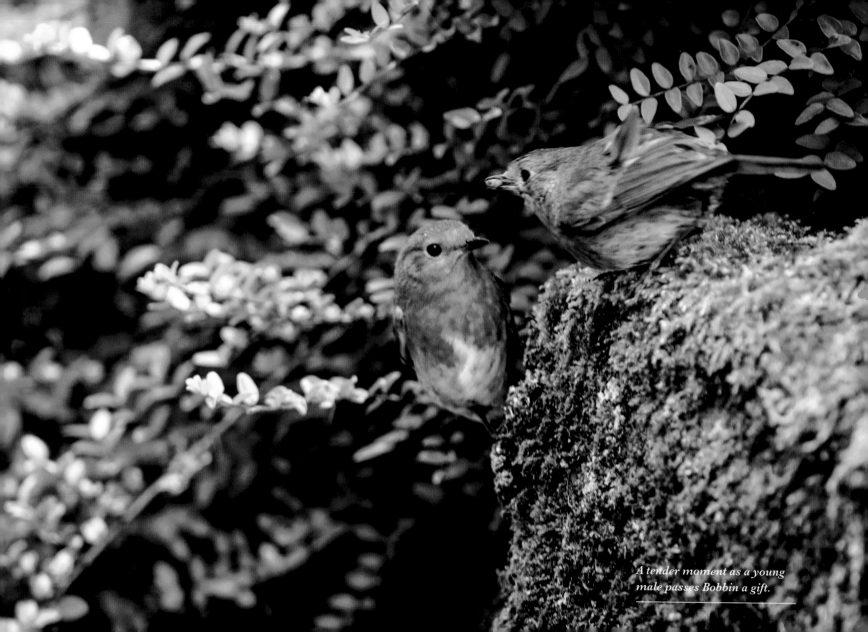

A tender moment as a young male passes Bobbin a gift.

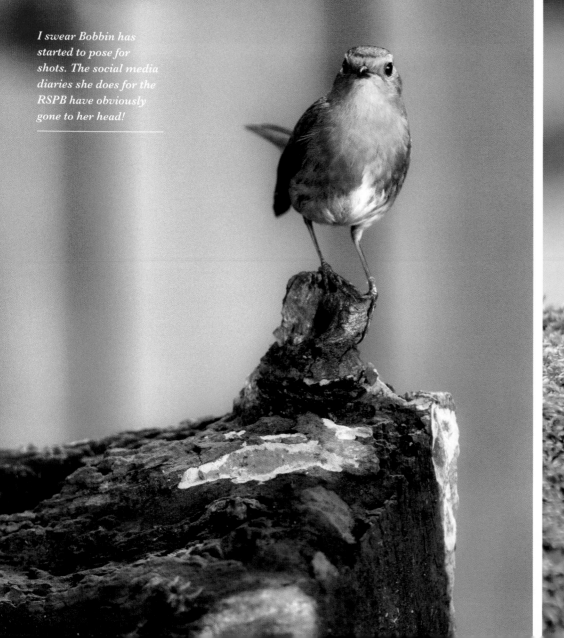

I swear Bobbin has started to pose for shots. The social media diaries she does for the RSPB have obviously gone to her head!

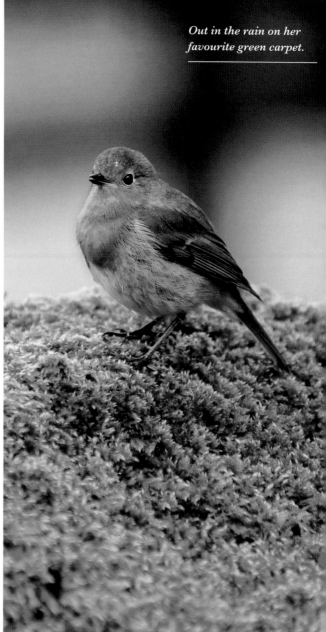

Out in the rain on her favourite green carpet.

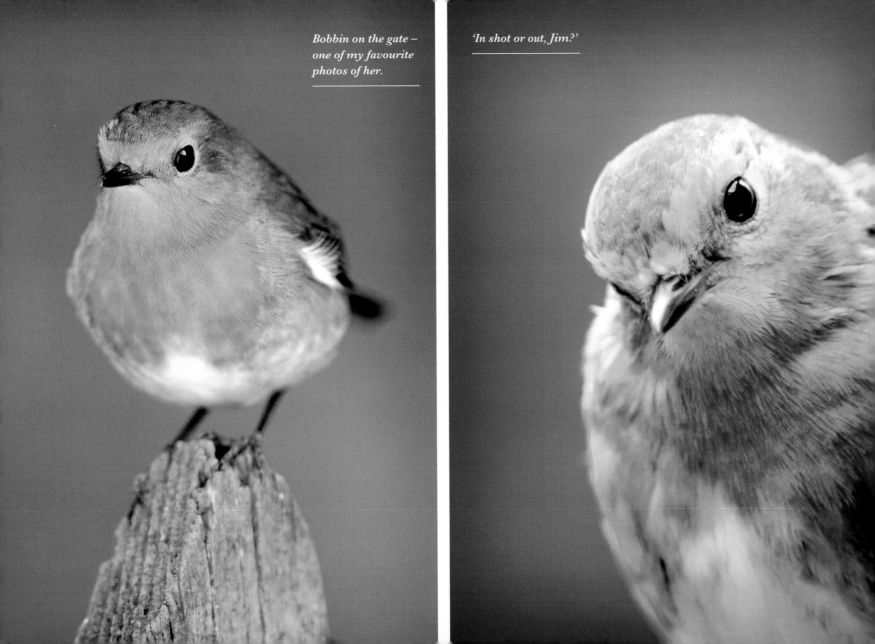

Bobbin on the gate – one of my favourite photos of her.

'In shot or out, Jim?'

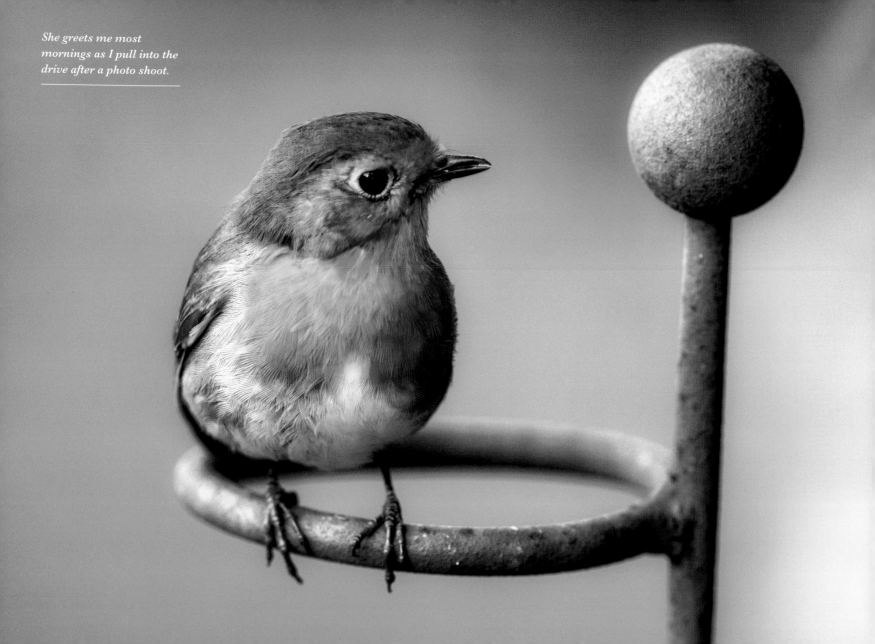

She greets me most mornings as I pull into the drive after a photo shoot.

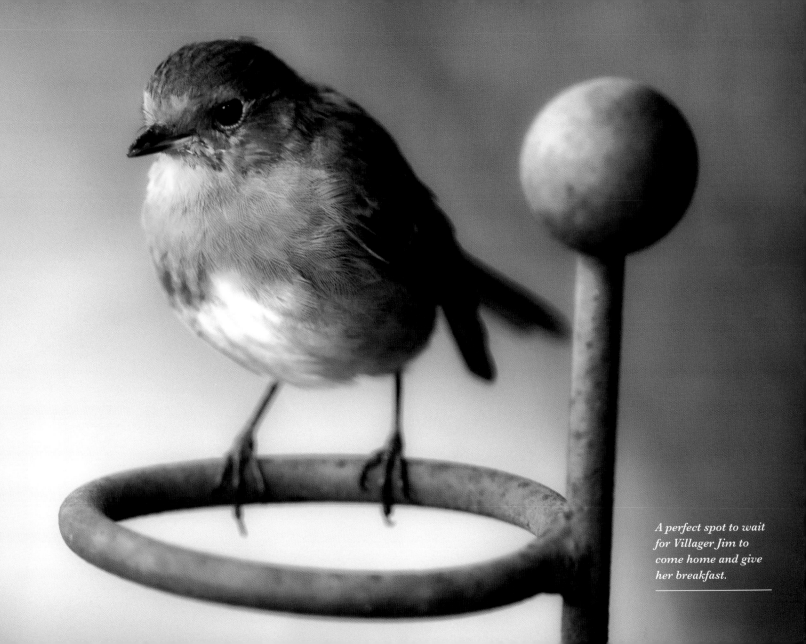

A perfect spot to wait for Villager Jim to come home and give her breakfast.

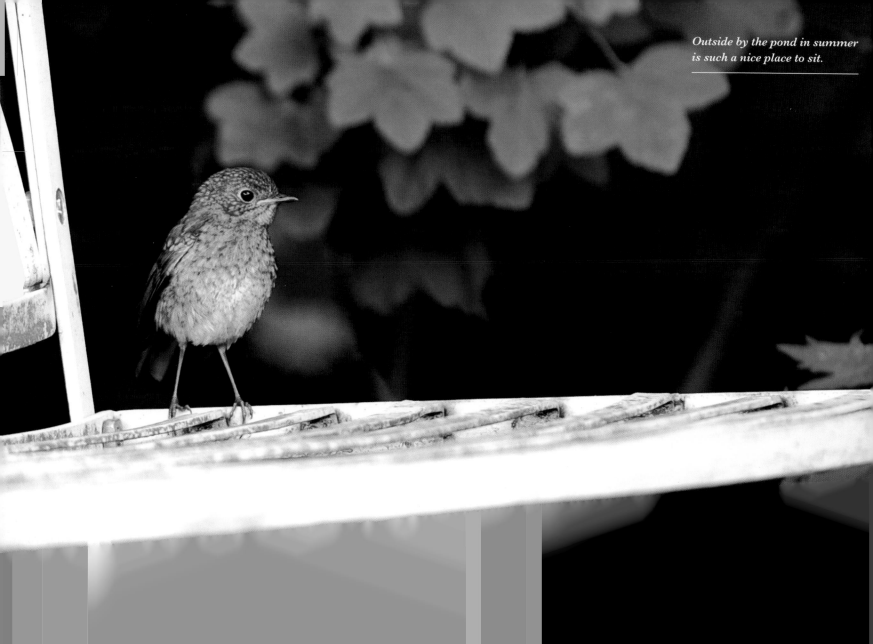

Outside by the pond in summer is such a nice place to sit.

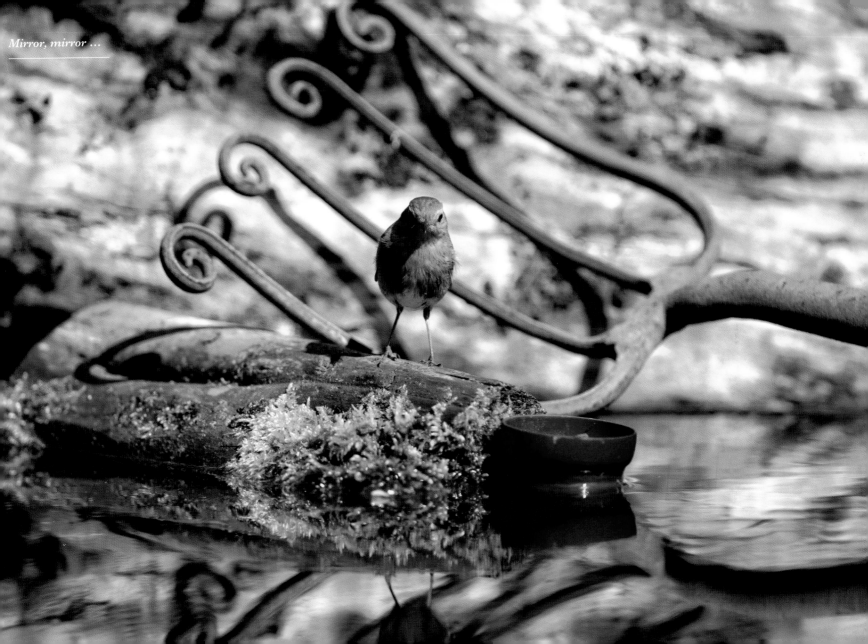

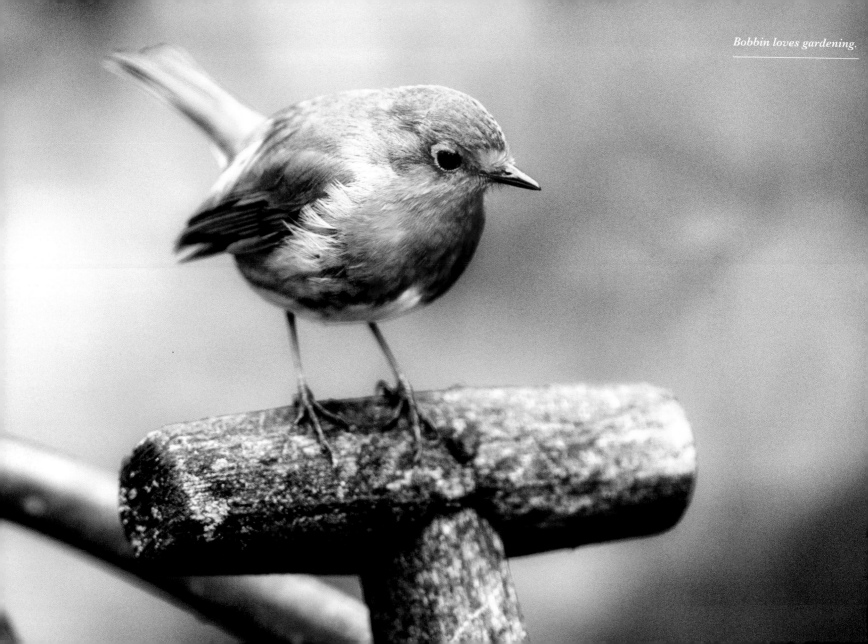

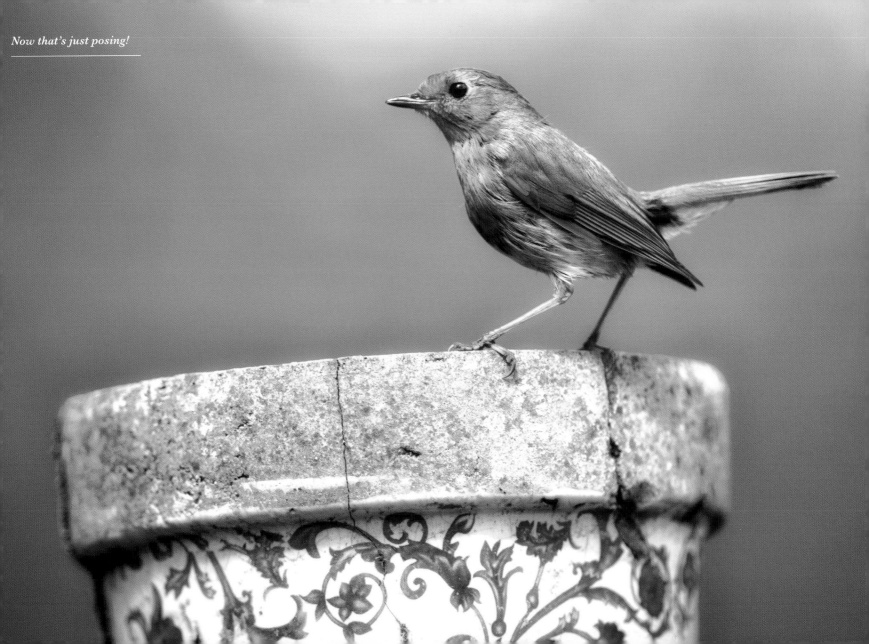

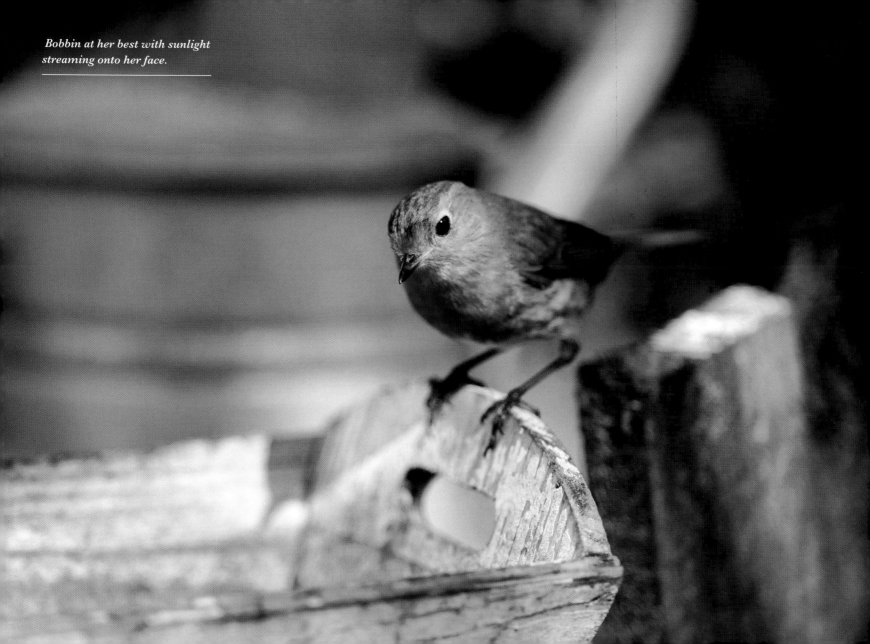

Bobbin at her best with sunlight streaming onto her face.

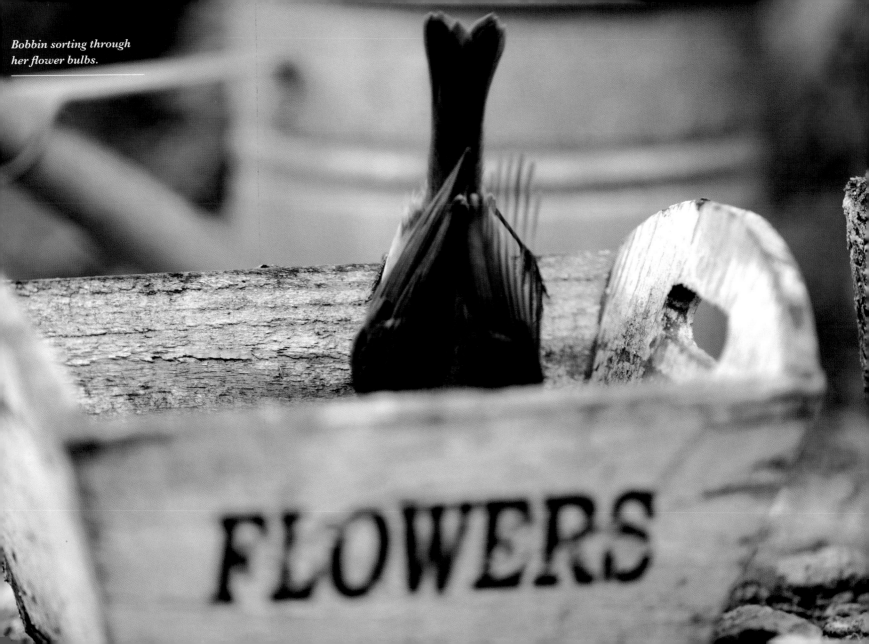

Bobbin sorting through her flower bulbs.

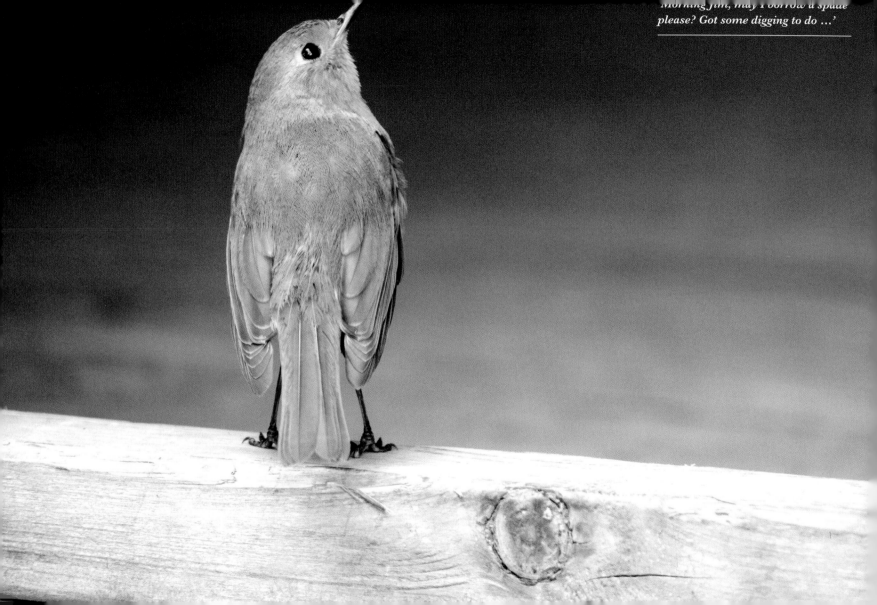

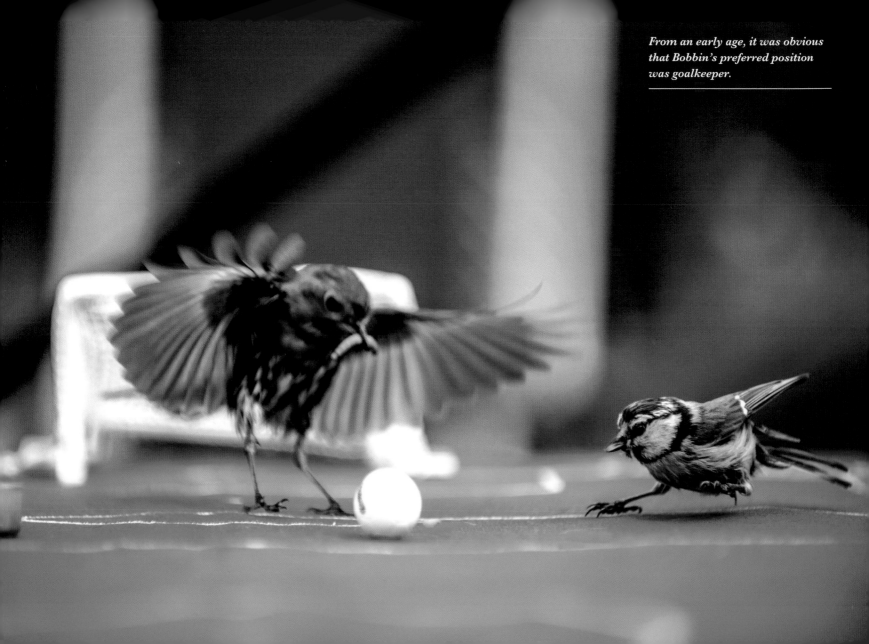

From an early age, it was obvious that Bobbin's preferred position was goalkeeper.

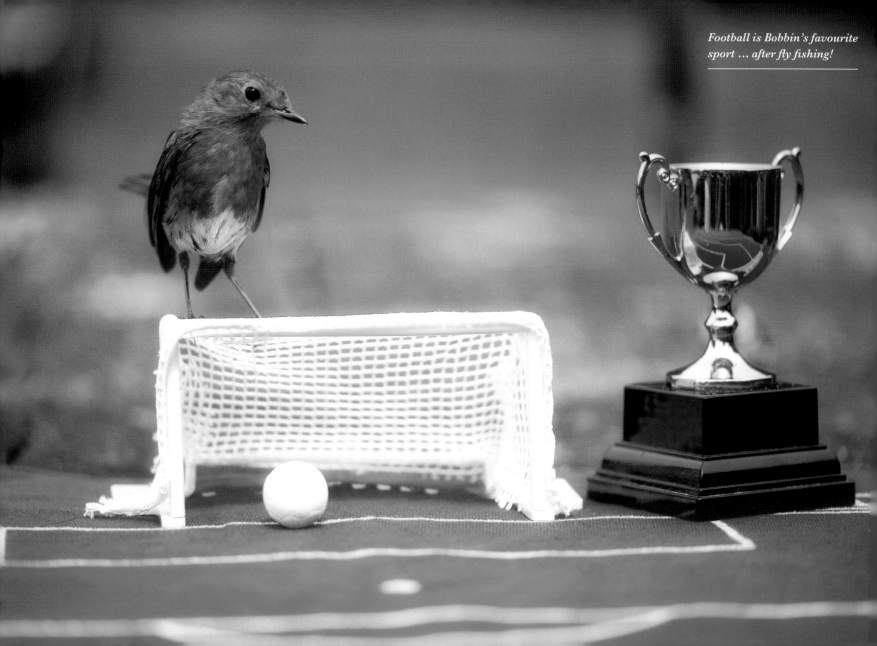

Football is Bobbin's favourite sport ... after fly fishing!

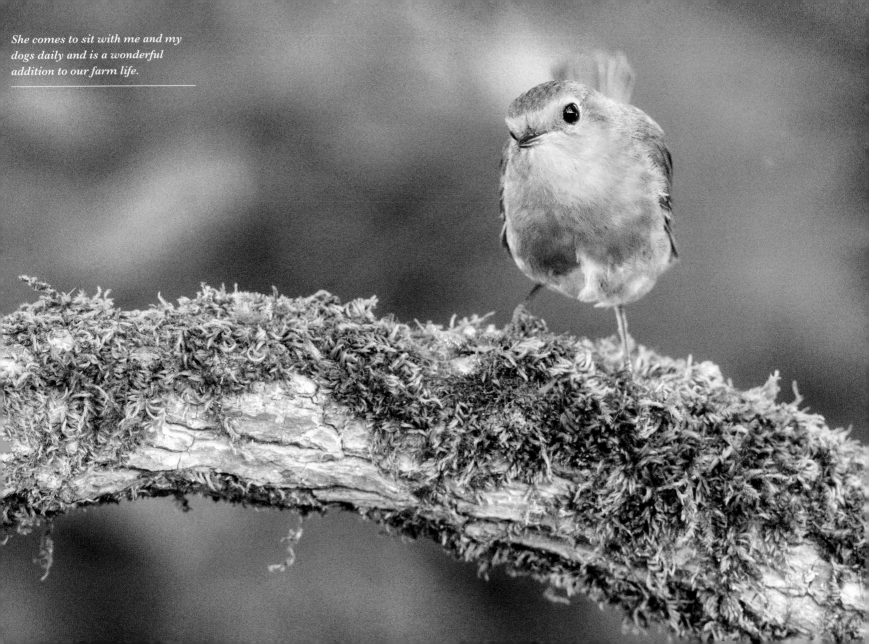

She comes to sit with me and my dogs daily and is a wonderful addition to our farm life.

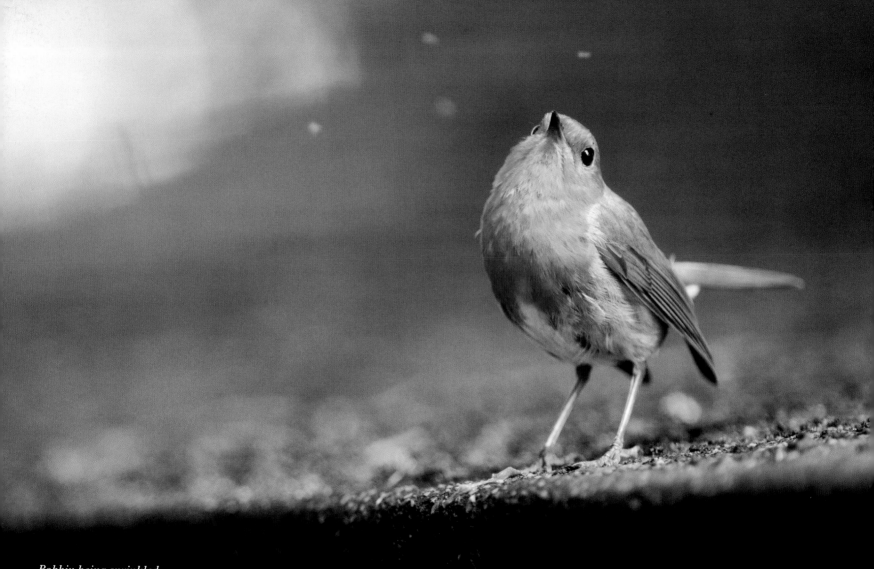

*Bobbin being sprinkled
with fairy dust.*

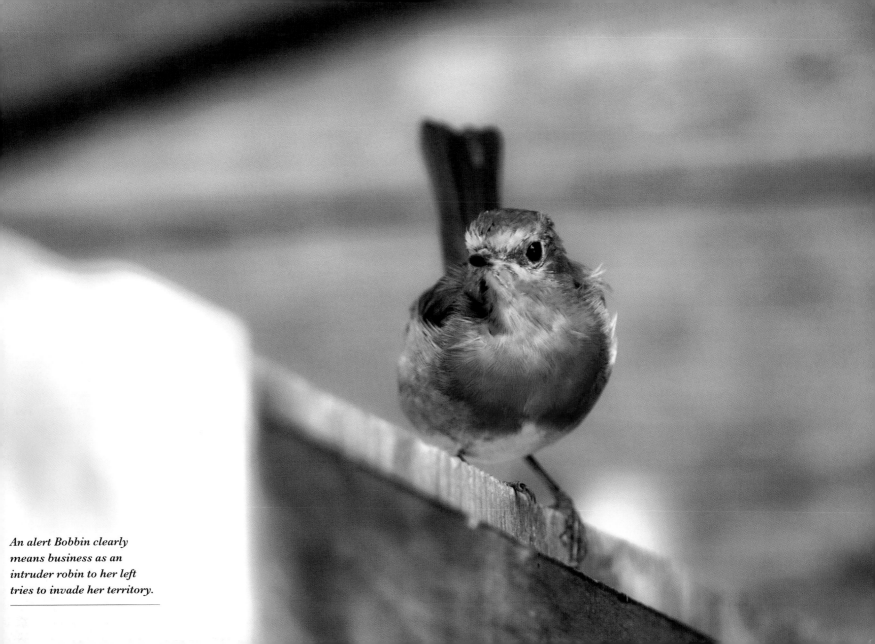

An alert Bobbin clearly means business as an intruder robin to her left tries to invade her territory.

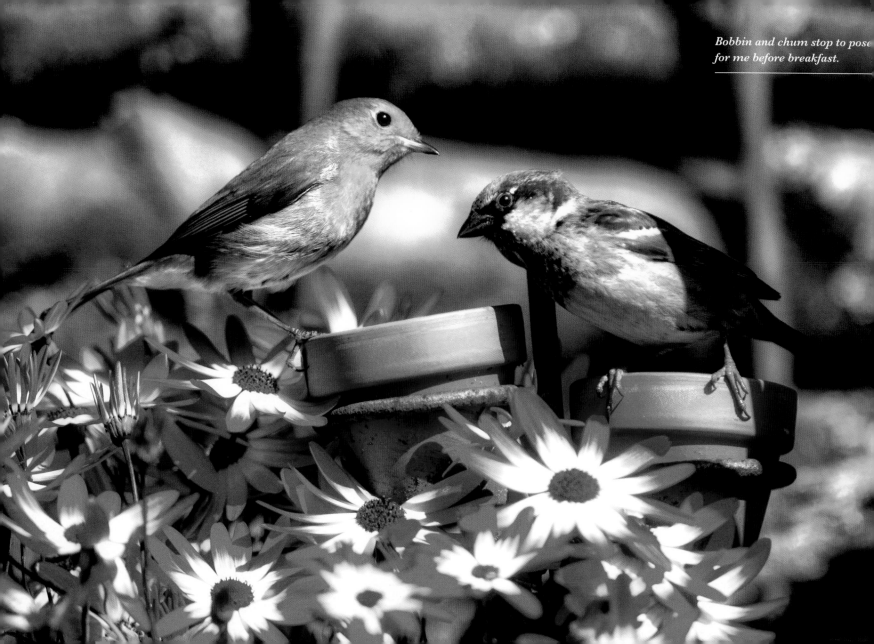

Straight out of the hairdressers.

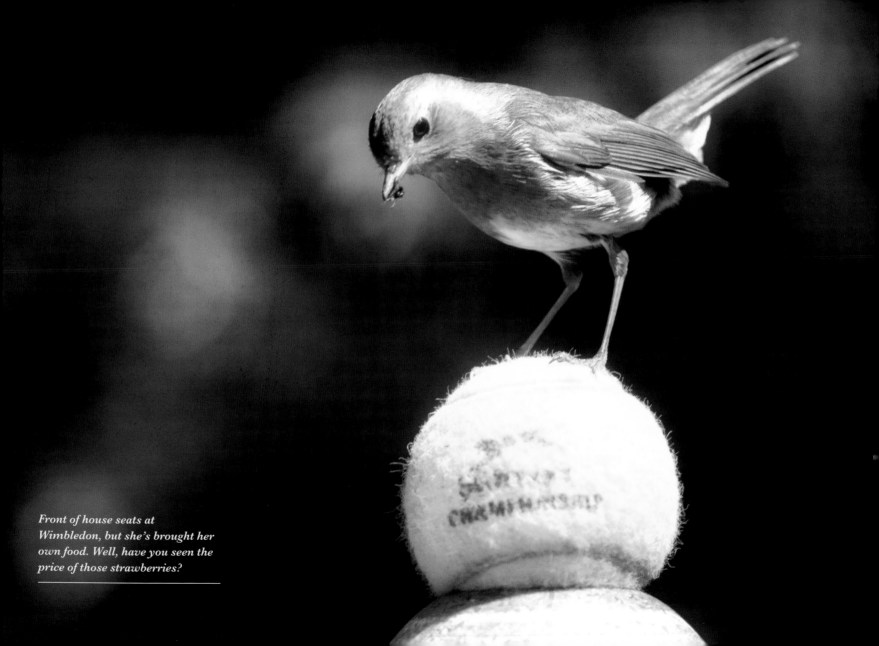

Front of house seats at Wimbledon, but she's brought her own food. Well, have you seen the price of those strawberries?

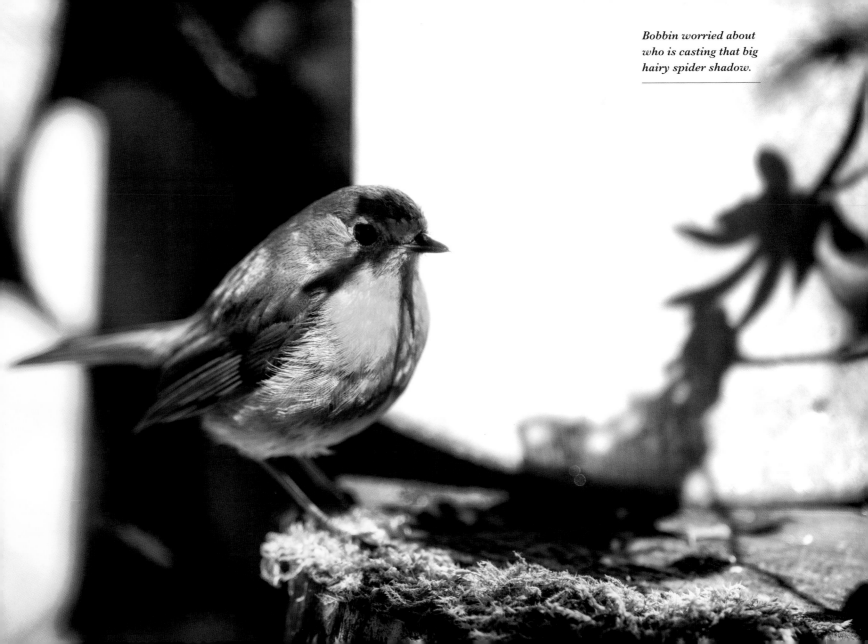

Bobbin worried about who is casting that big hairy spider shadow.

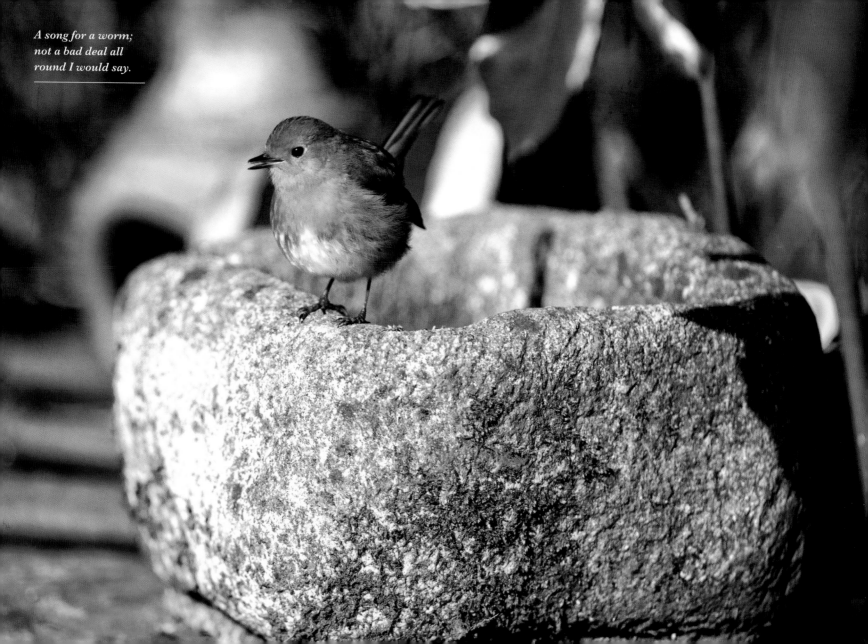

*A song for a worm;
not a bad deal all
round I would say.*

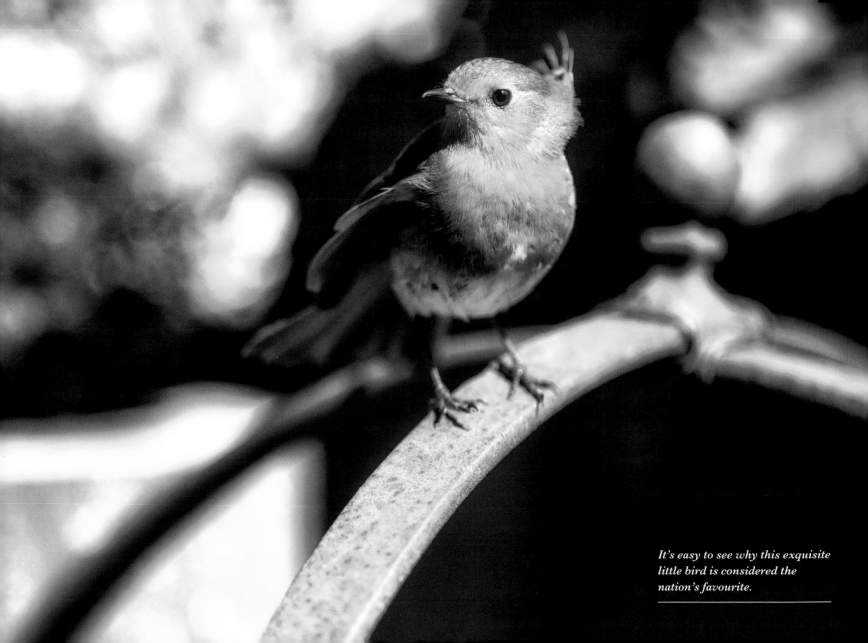

It's easy to see why this exquisite little bird is considered the nation's favourite.

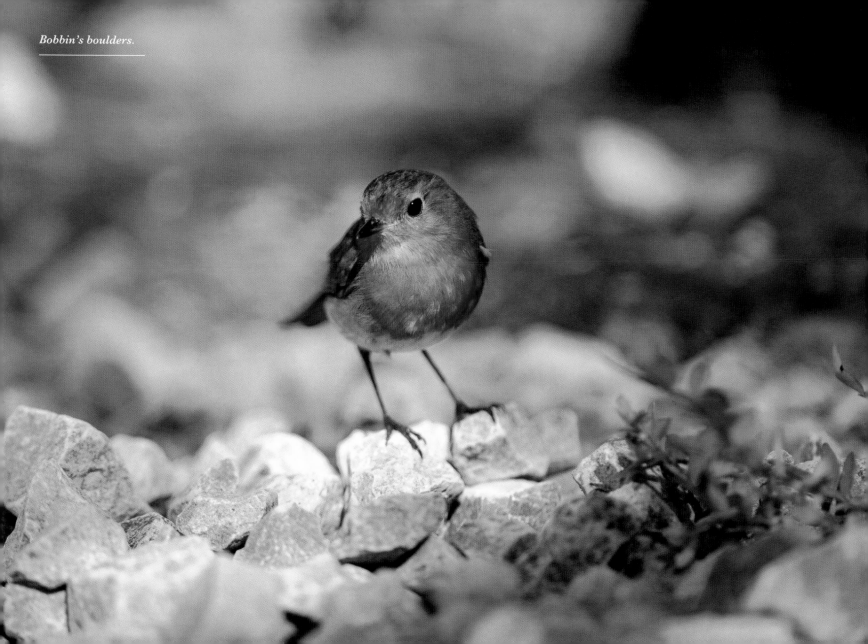

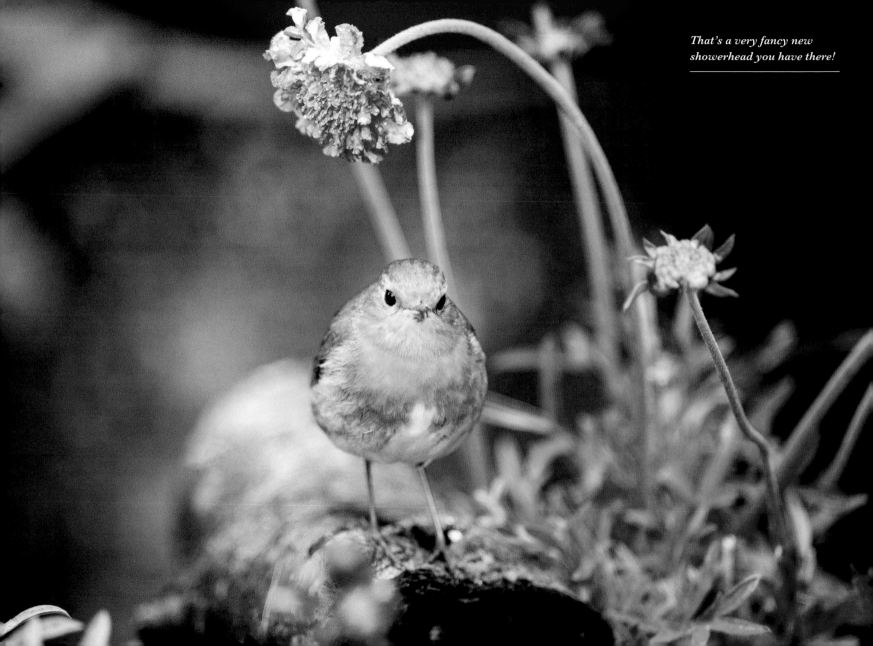

That's a very fancy new showerhead you have there!

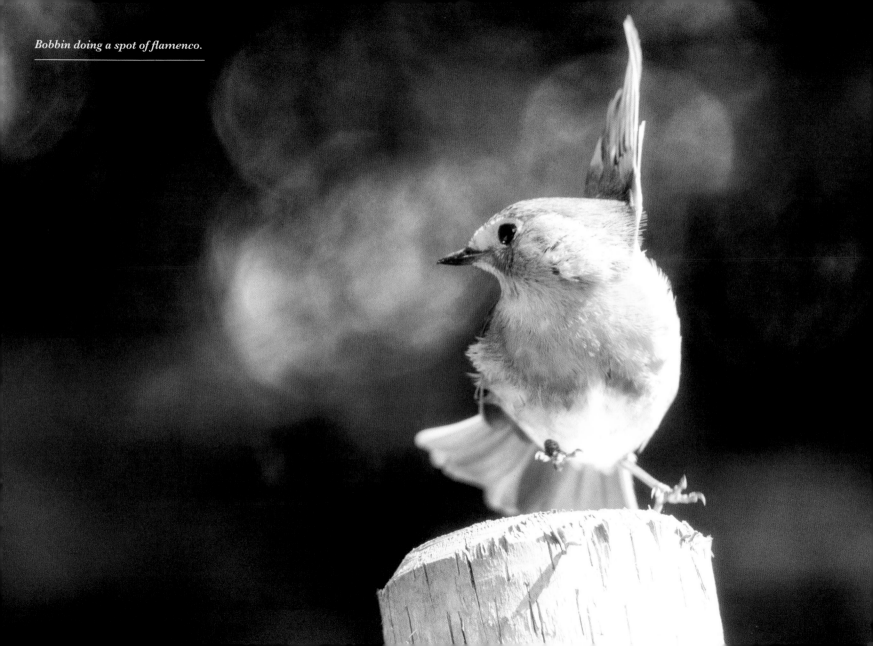

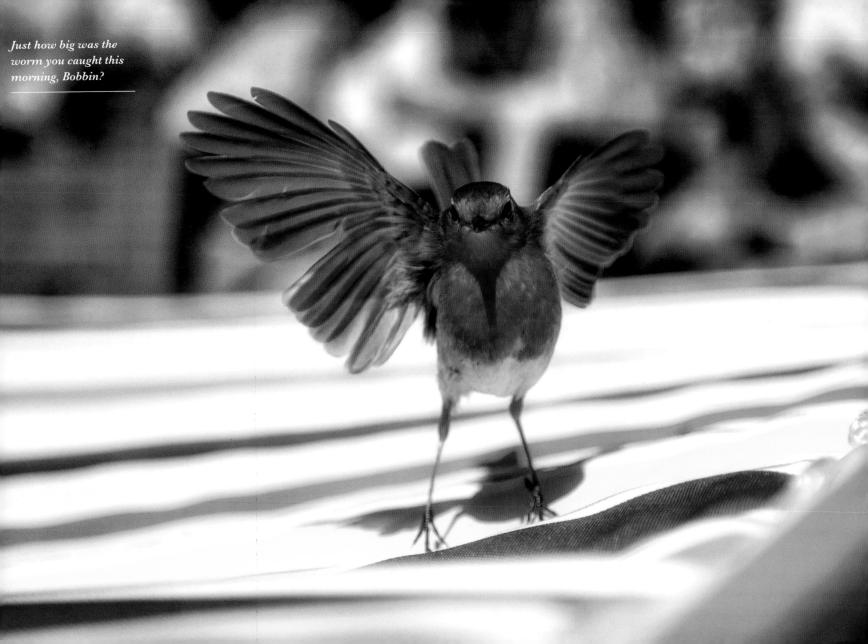

Just how big was the worm you caught this morning, Bobbin?

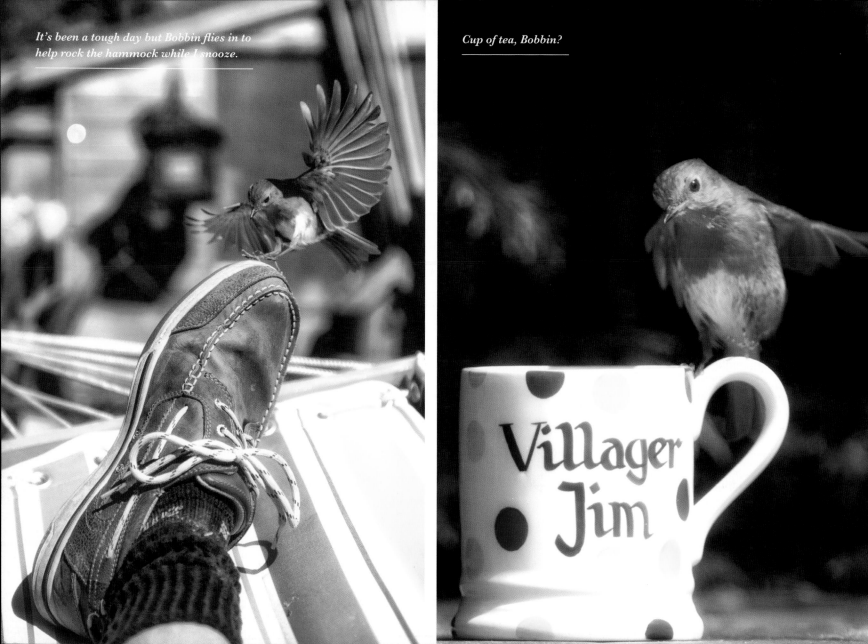

It's been a tough day but Bobbin flies in to help rock the hammock while I snooze.

Cup of tea, Bobbin?

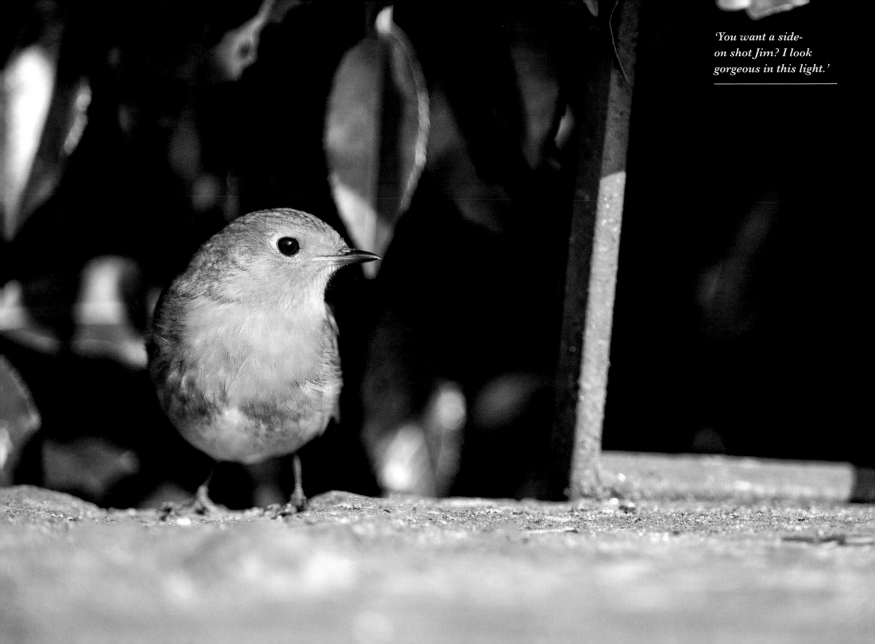

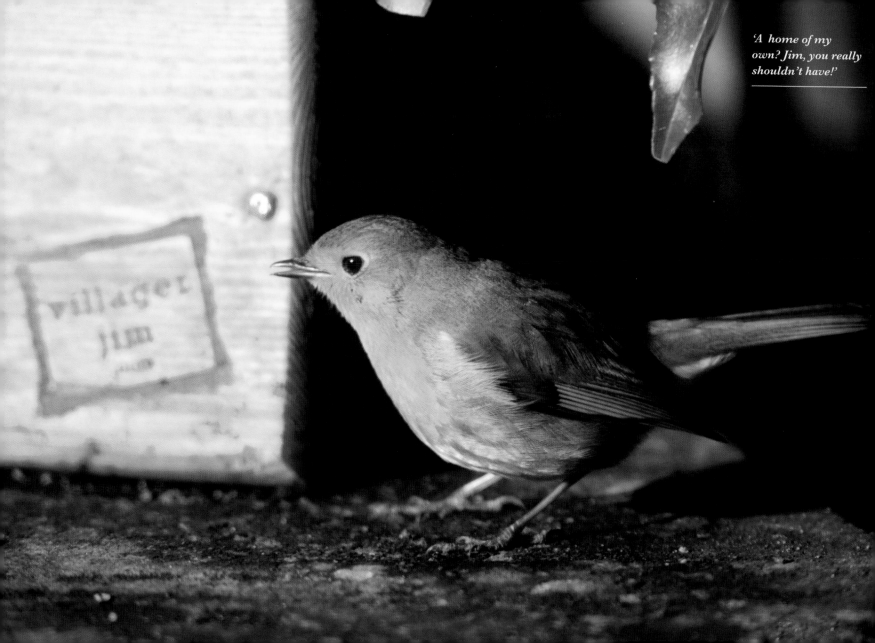

'A home of my own? Jim, you really shouldn't have!'

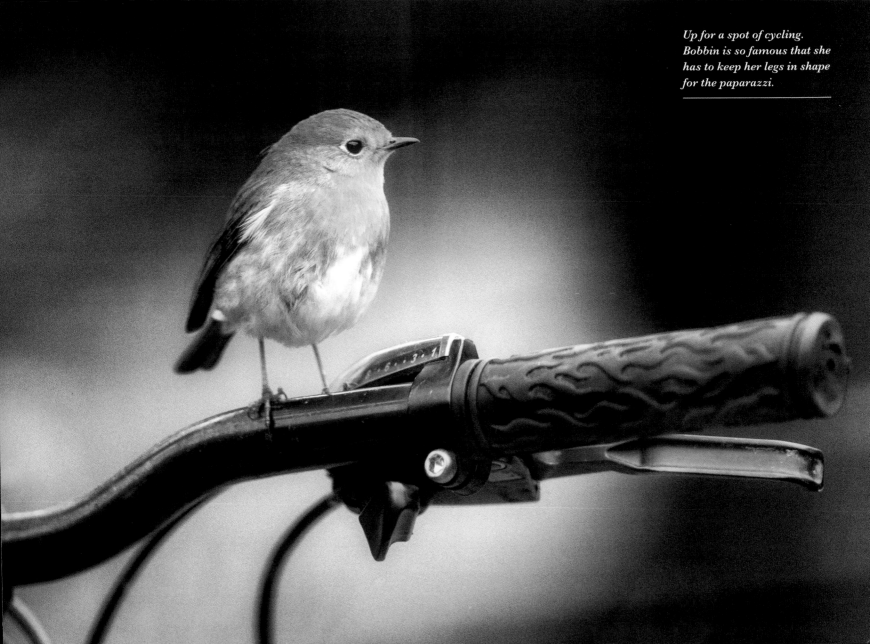

Up for a spot of cycling. Bobbin is so famous that she has to keep her legs in shape for the paparazzi.

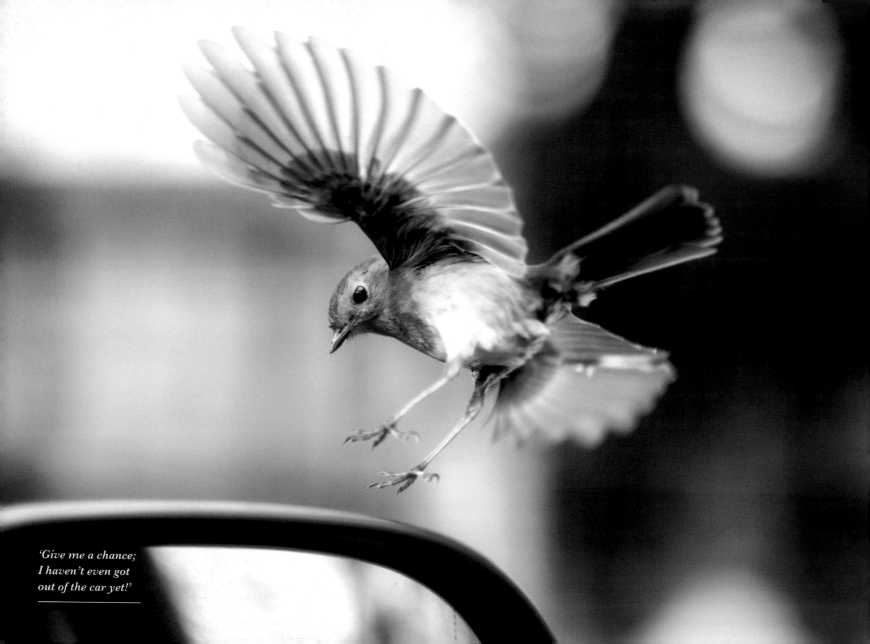

'Give me a chance;
I haven't even got
out of the car yet!'

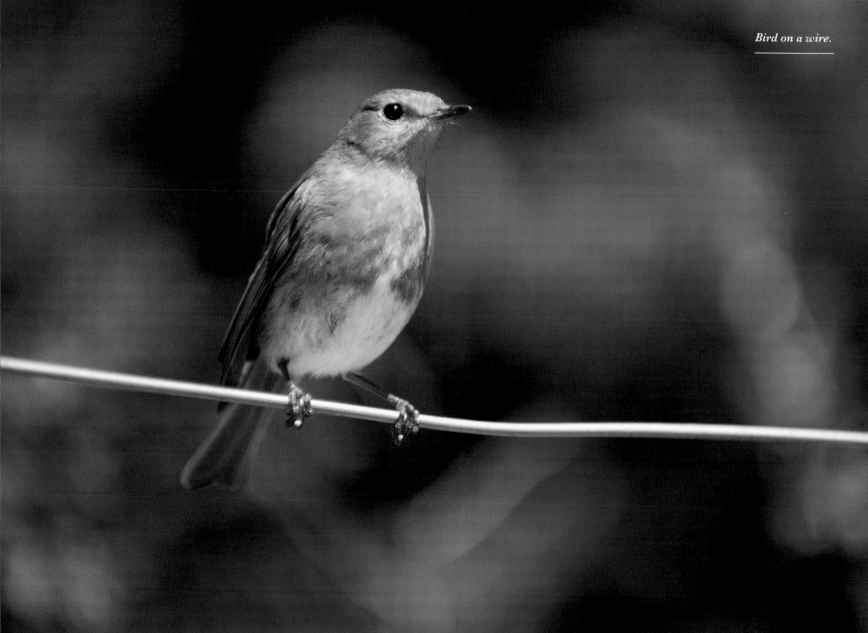

Bird on a wire.

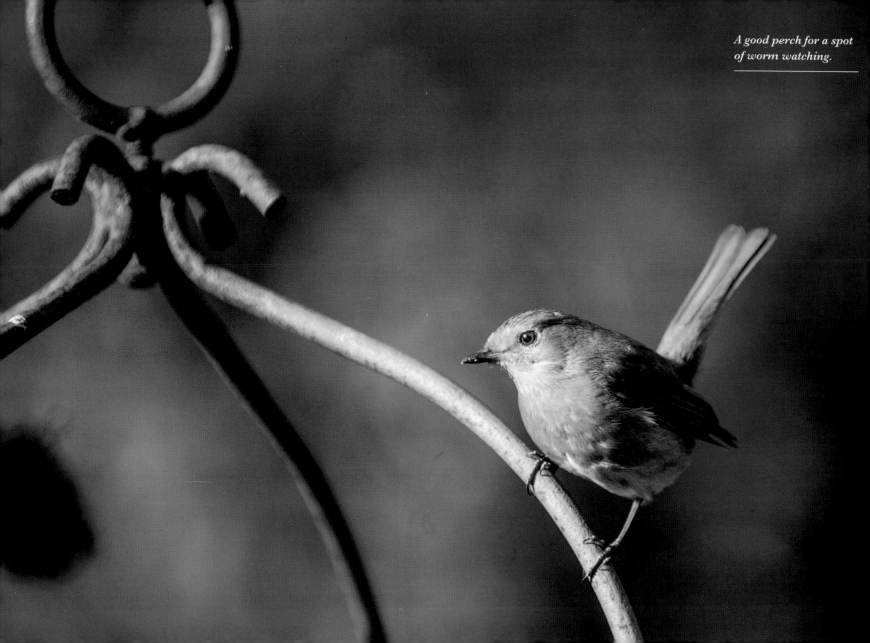

A good perch for a spot of worm watching.

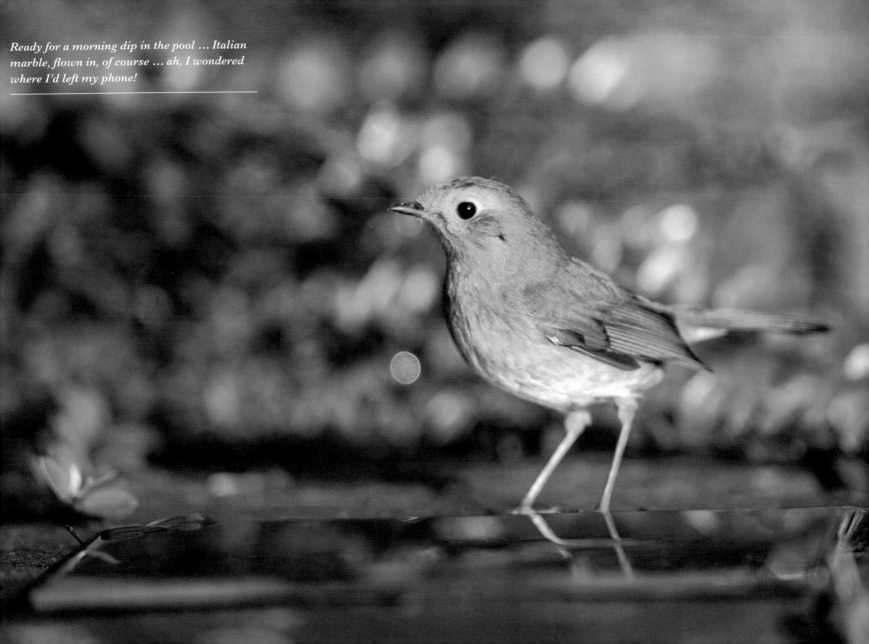

Ready for a morning dip in the pool ... Italian marble, flown in, of course ... ah, I wondered where I'd left my phone!

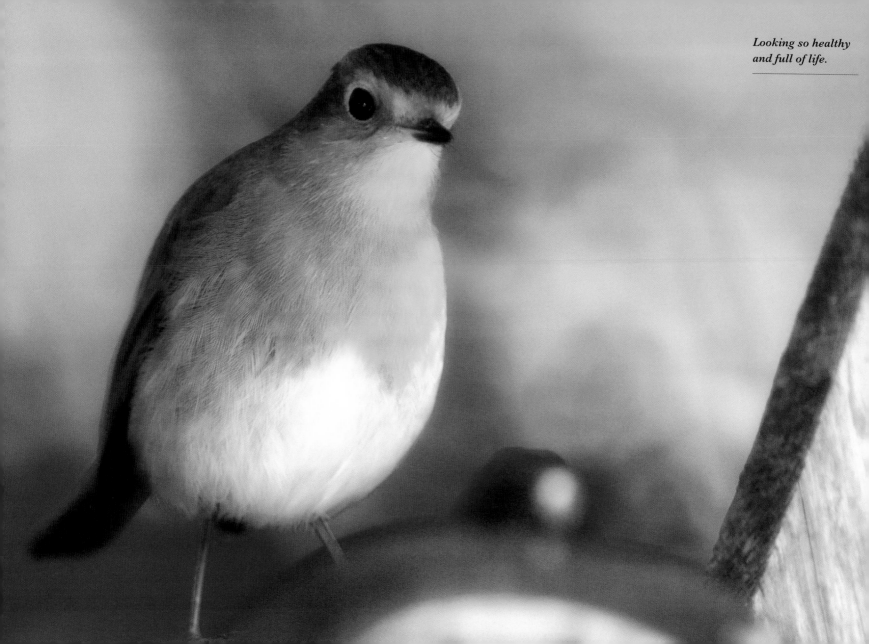

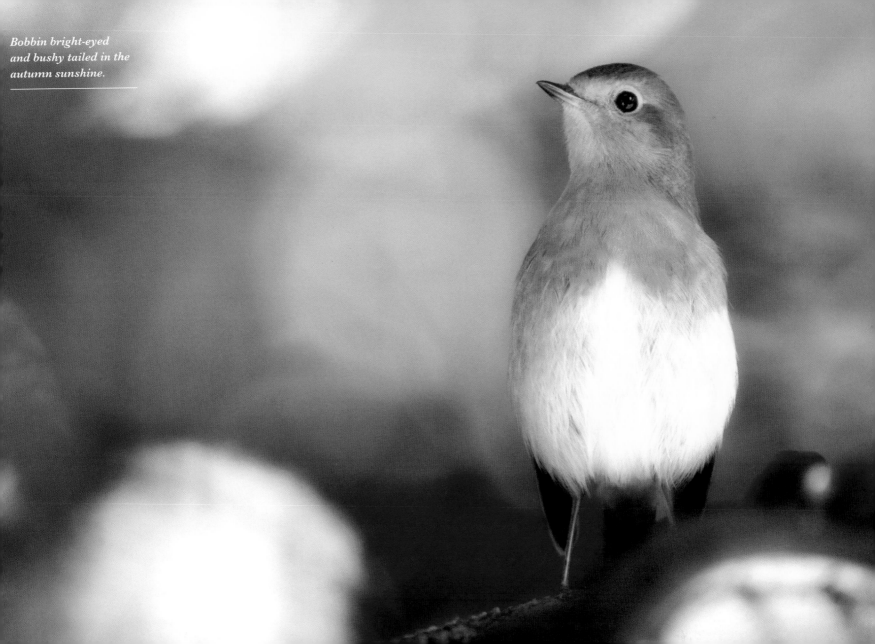

Bobbin bright-eyed and bushy tailed in the autumn sunshine.

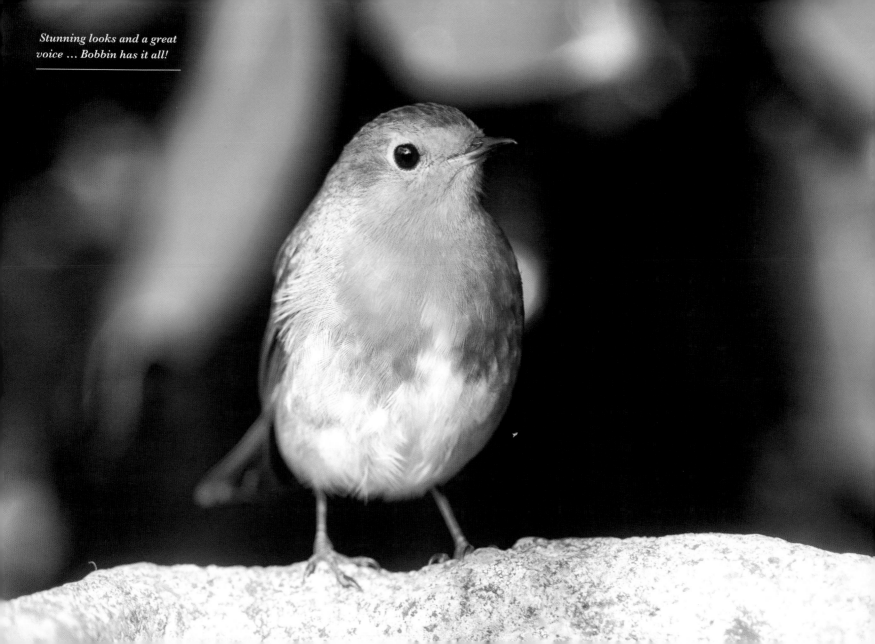

Stunning looks and a great voice ... Bobbin has it all!

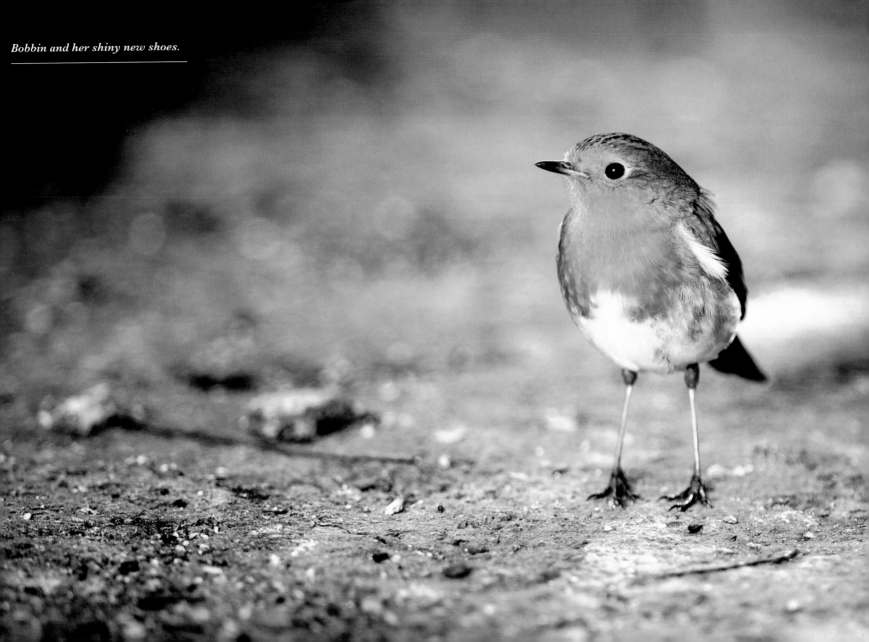

Bobbin and her shiny new shoes.

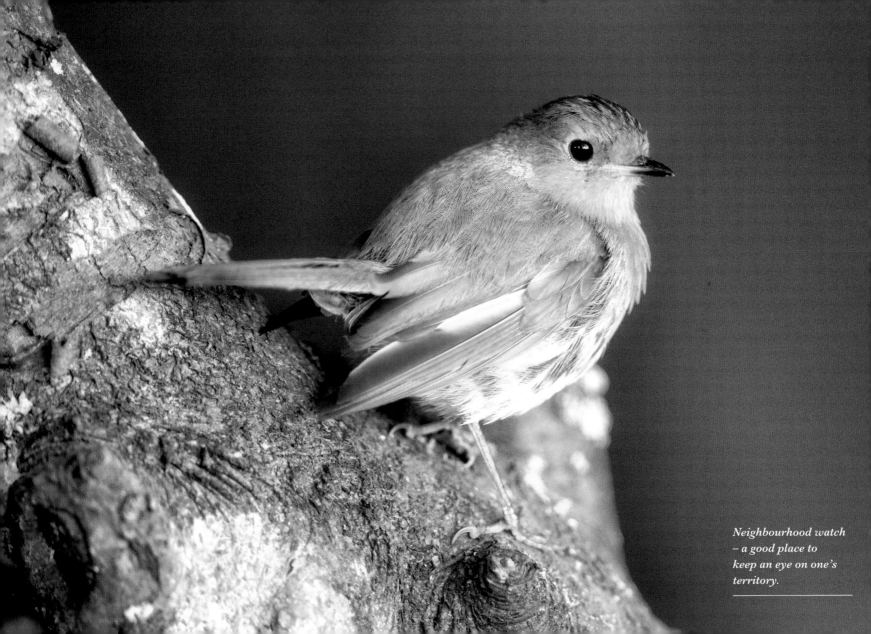

Neighbourhood watch – a good place to keep an eye on one's territory.

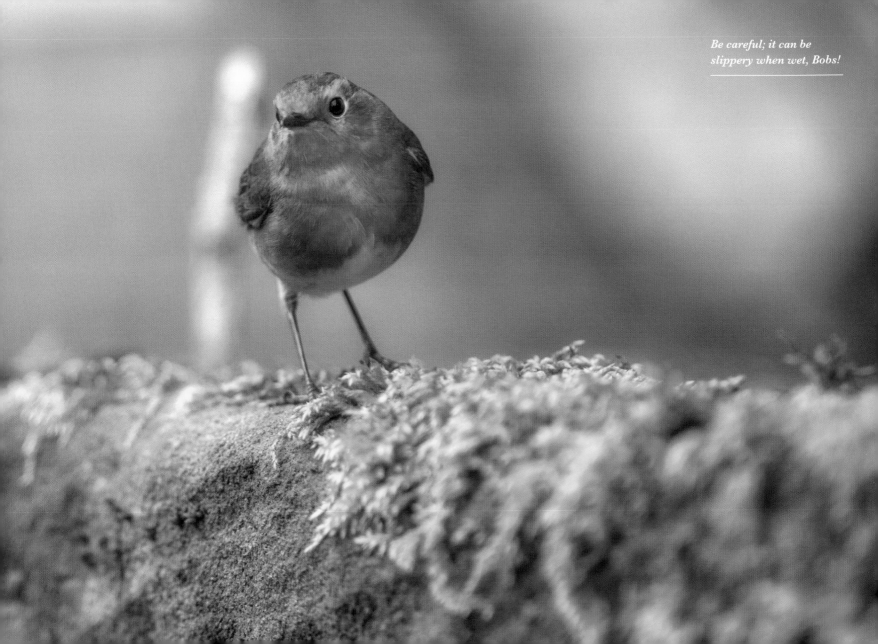

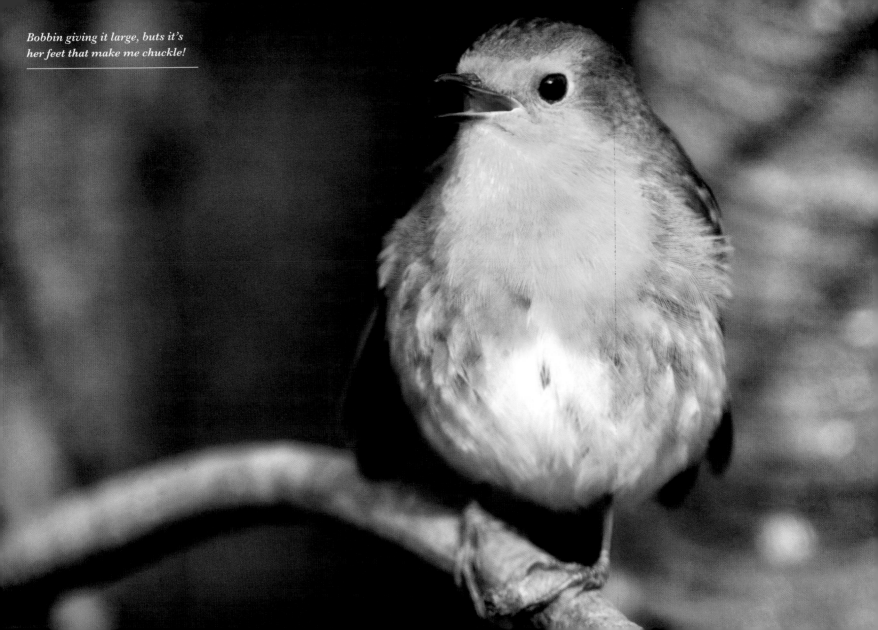

Bobbin giving it large, buts it's her feet that make me chuckle!

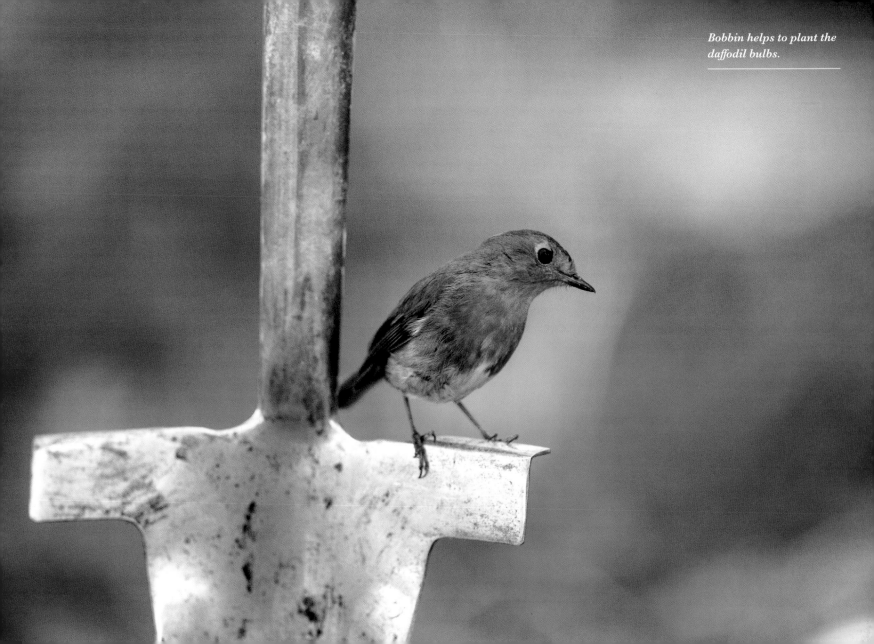

Bobbin helps to plant the daffodil bulbs.

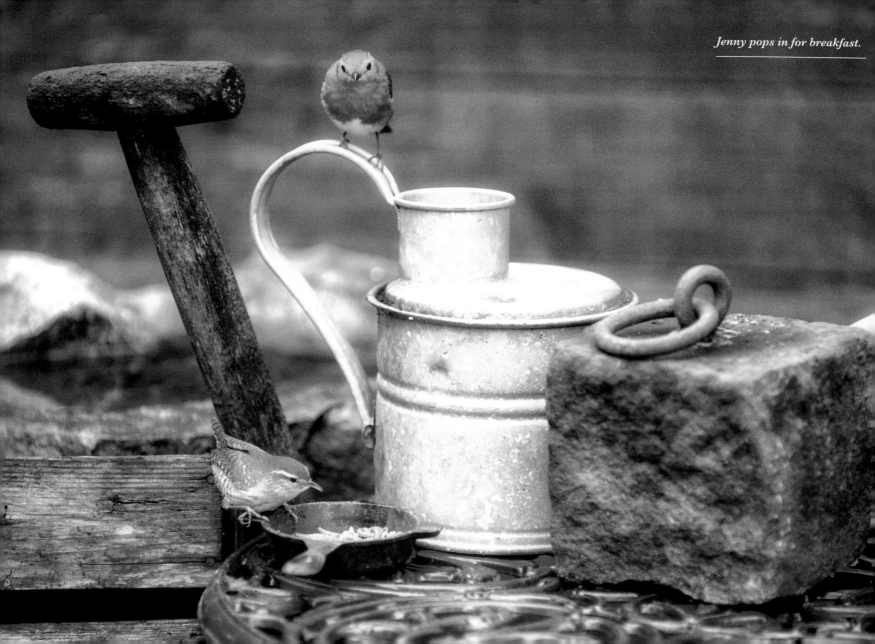

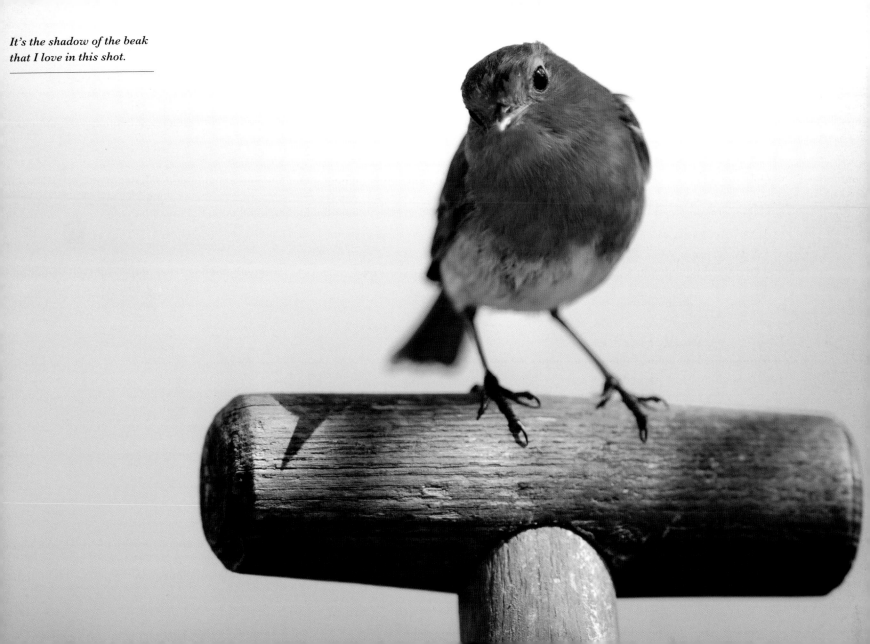

It's the shadow of the beak that I love in this shot.

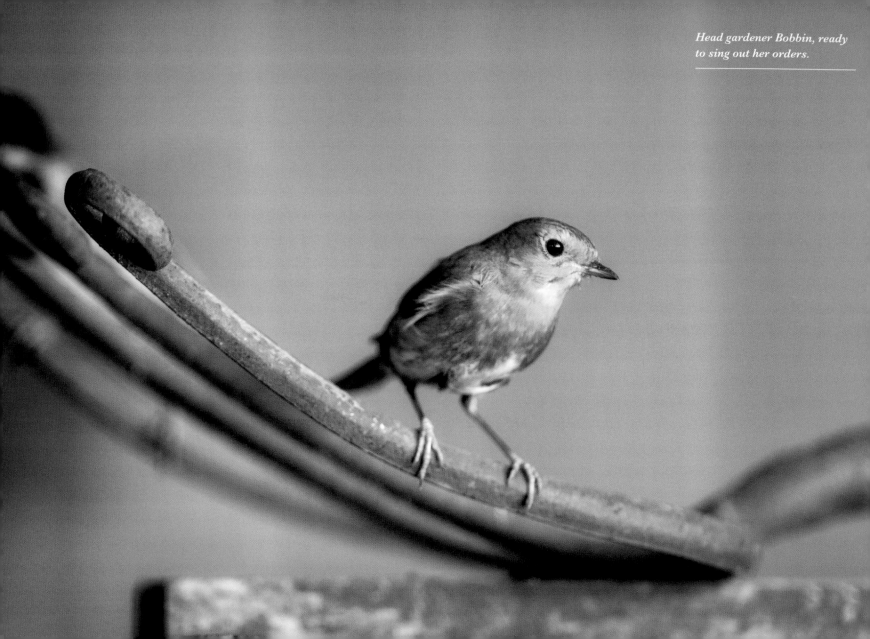

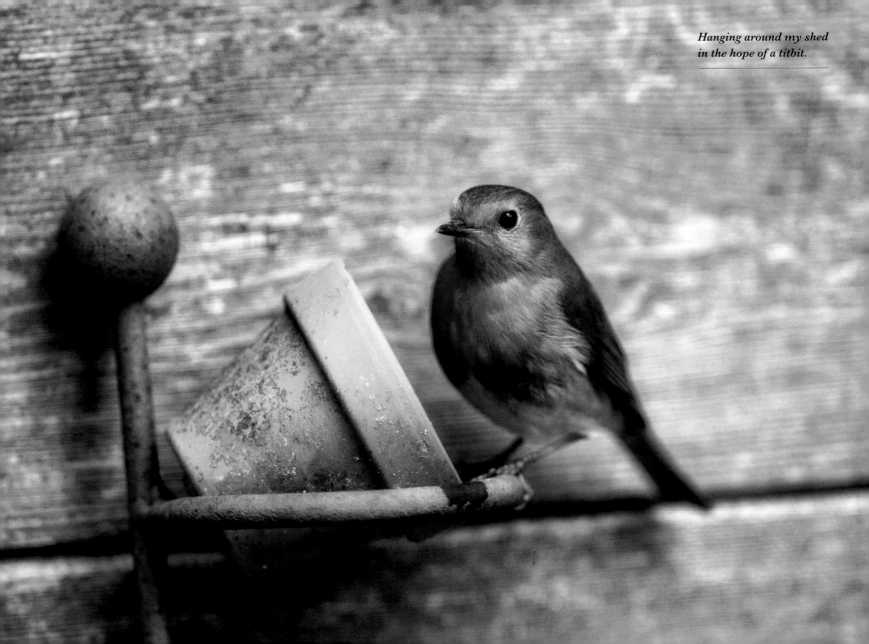

*Hanging around my shed
in the hope of a titbit.*

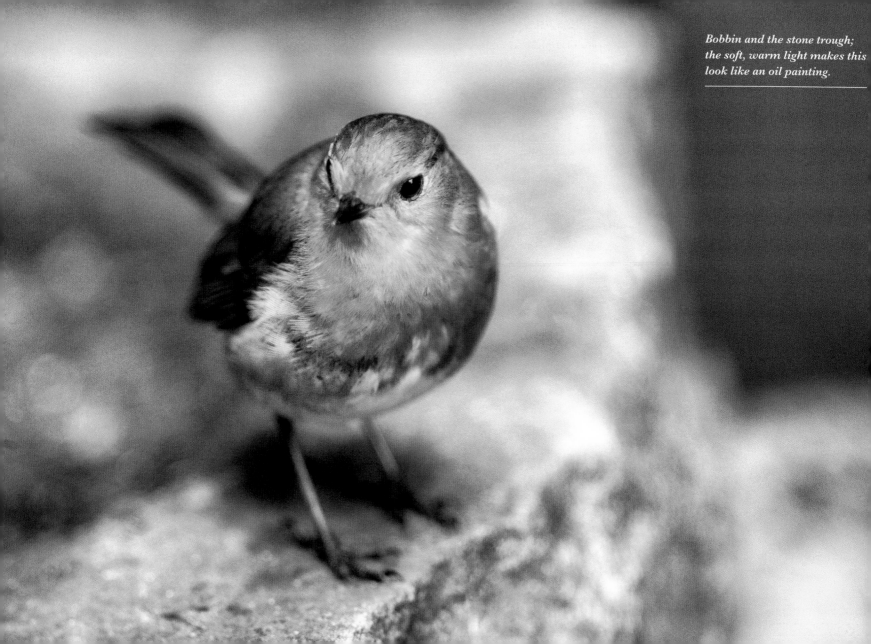

Bobbin and the stone trough; the soft, warm light makes this look like an oil painting.

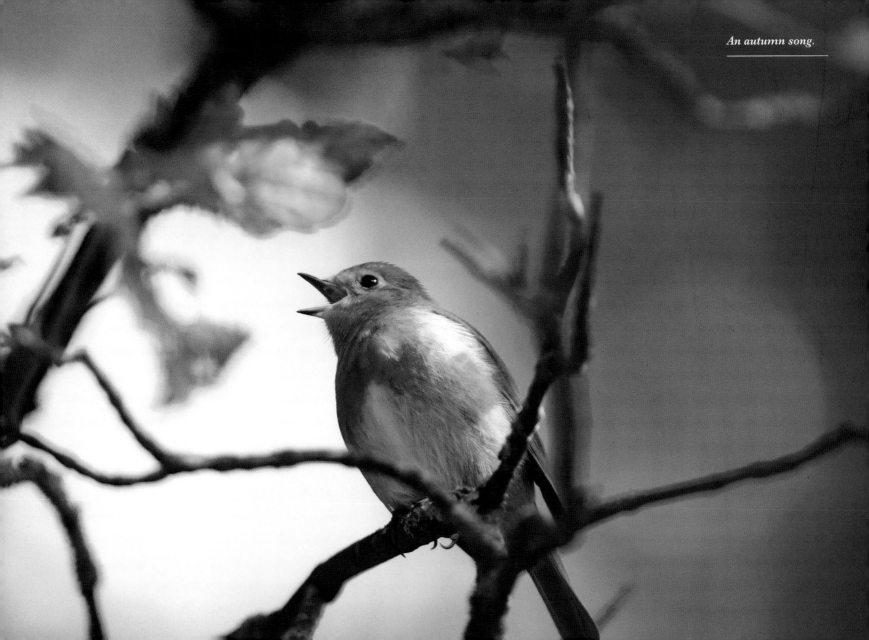

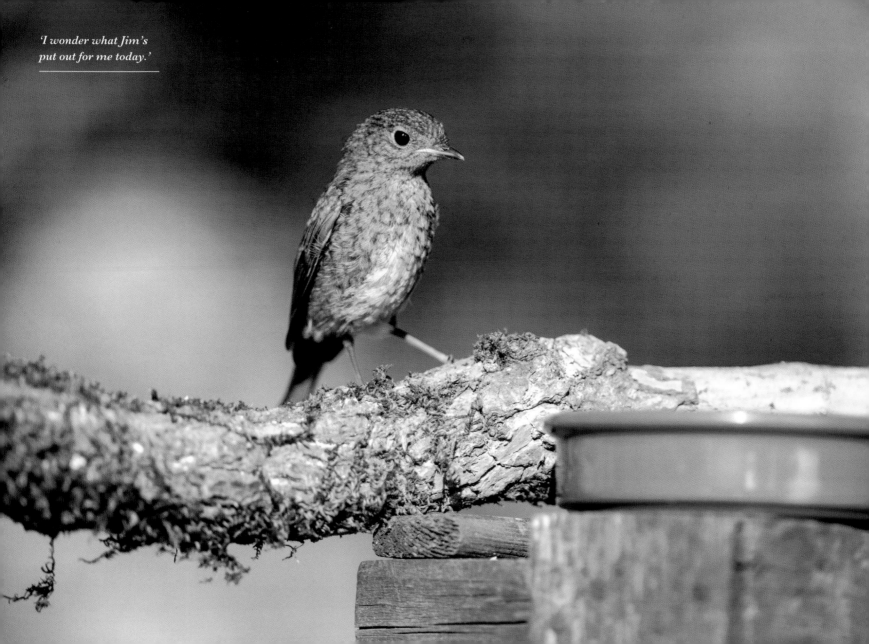

*'I wonder what Jim's
put out for me today.'*

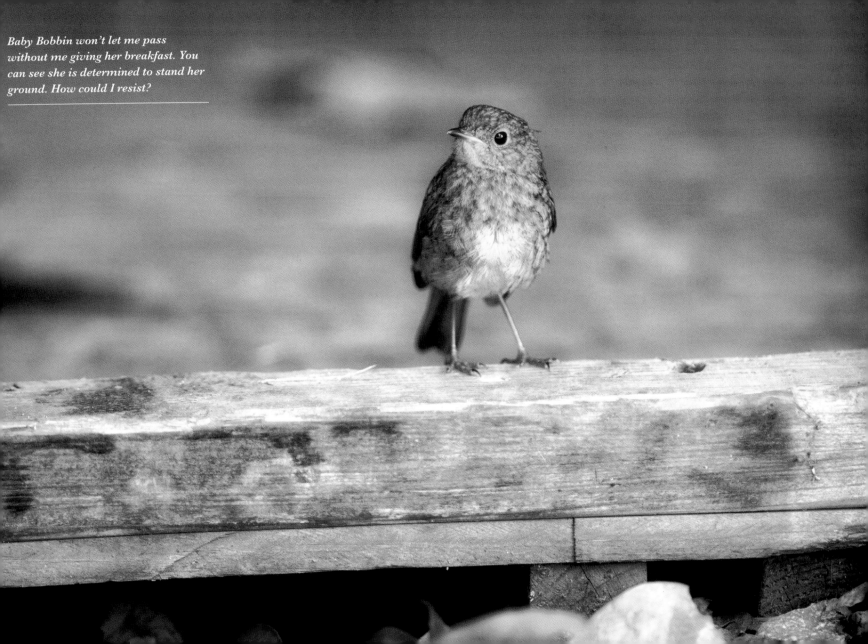

Baby Bobbin won't let me pass without me giving her breakfast. You can see she is determined to stand her ground. How could I resist?

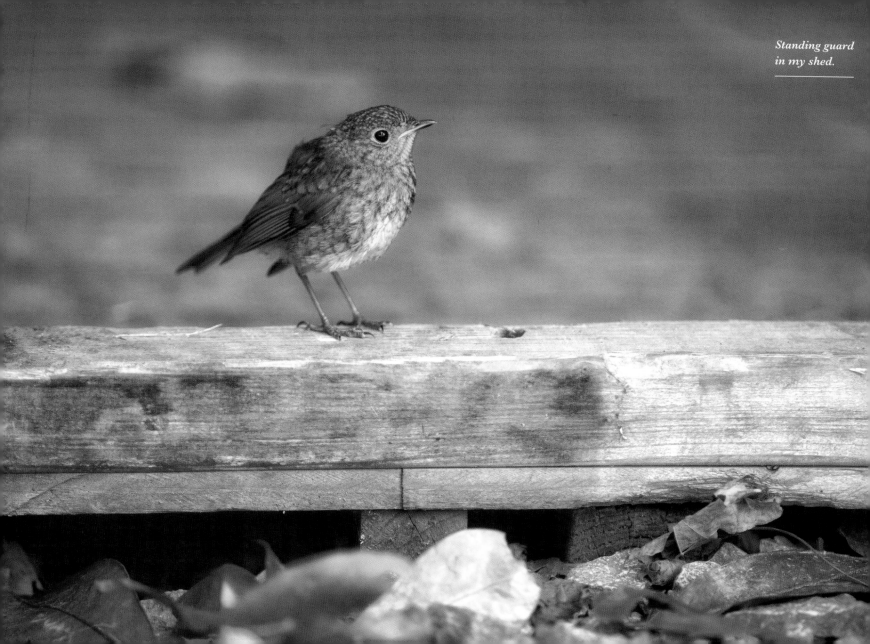

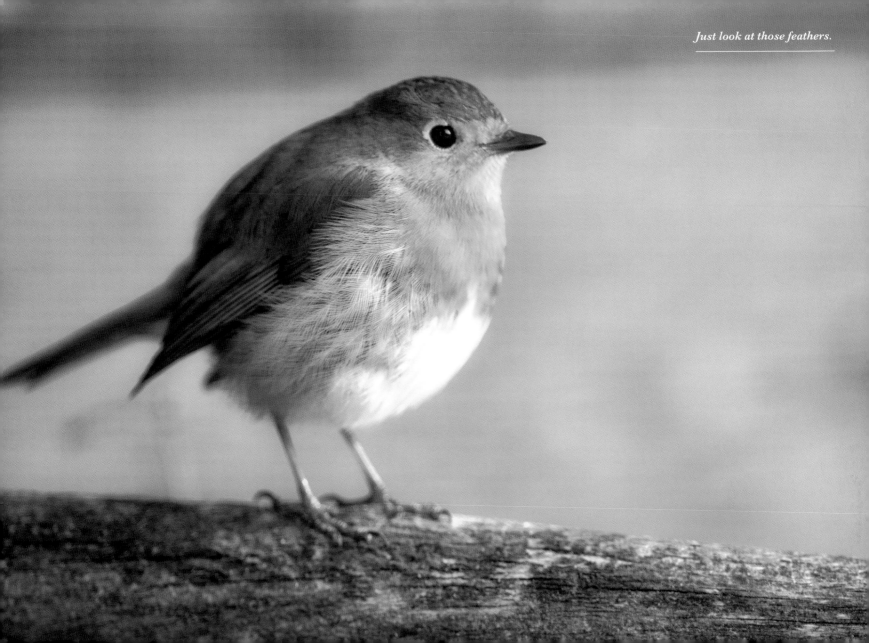

Just look at those feathers.

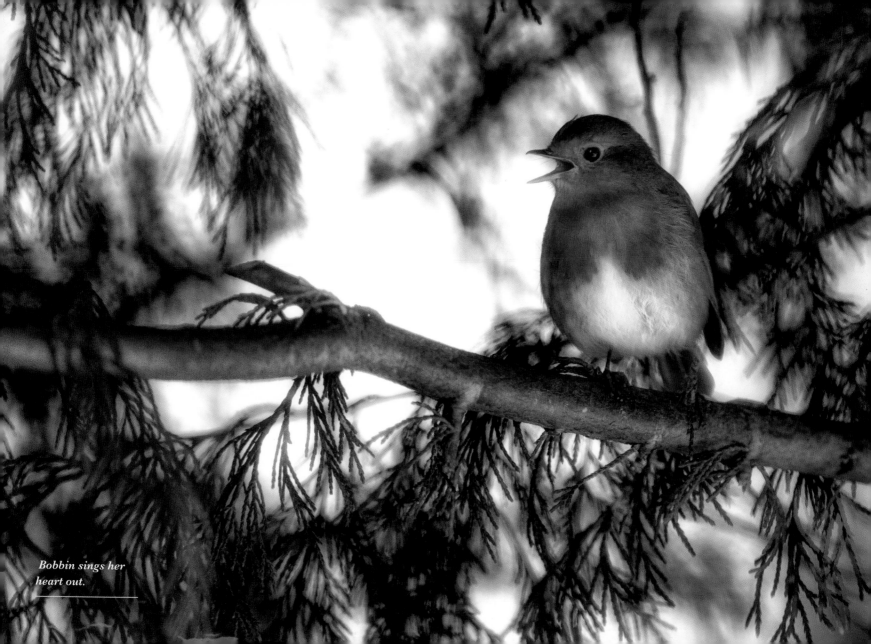

Bobbin sings her
heart out.

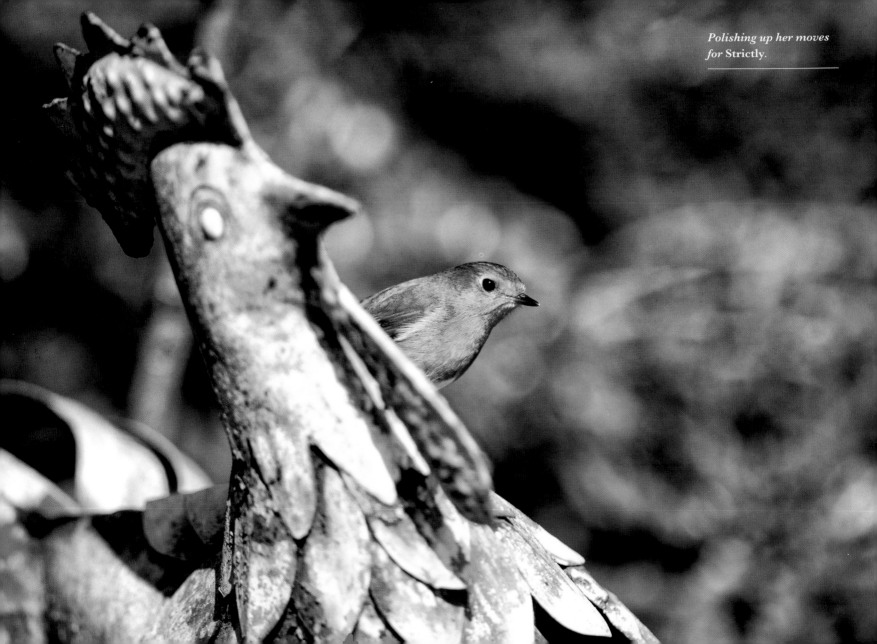

Polishing up her moves for Strictly.

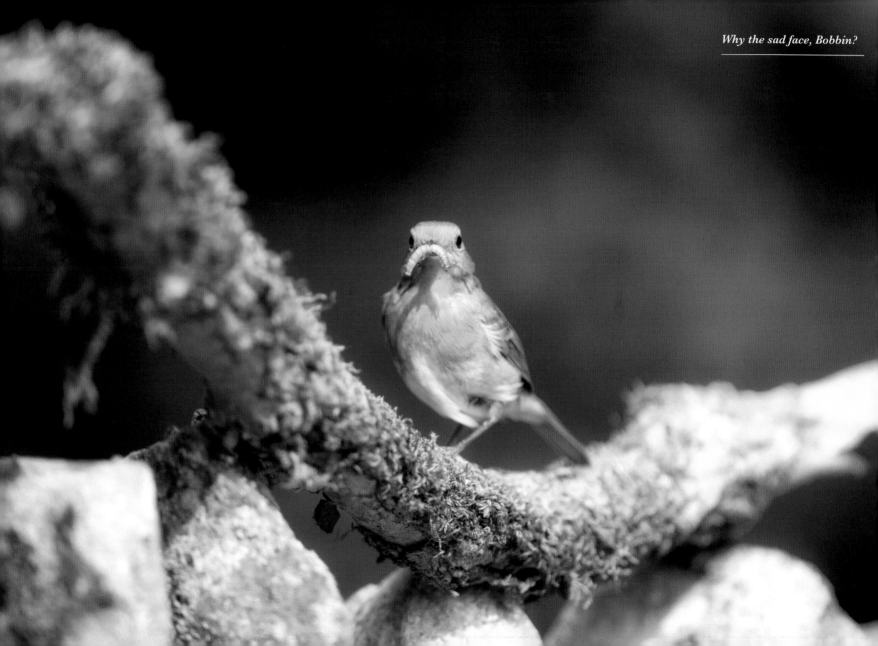

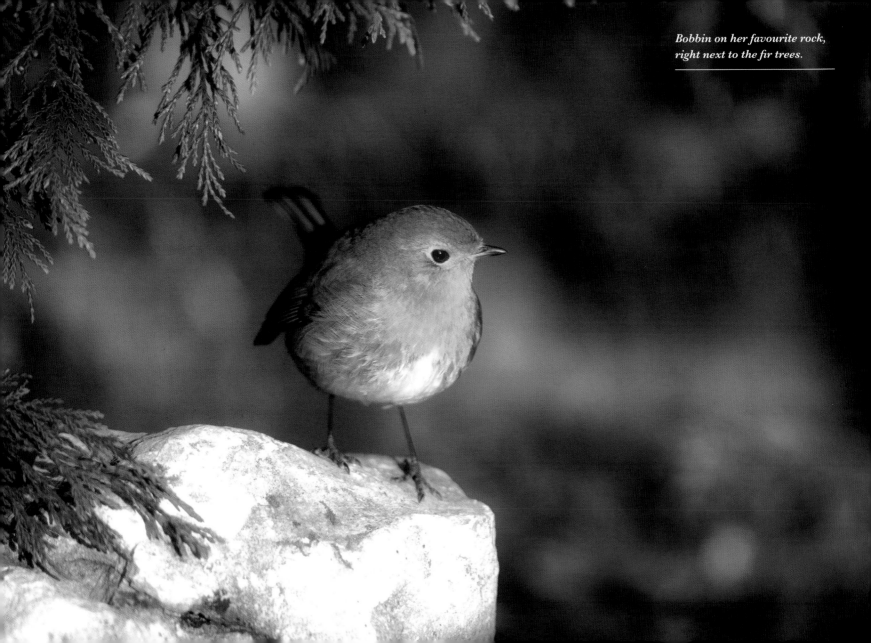

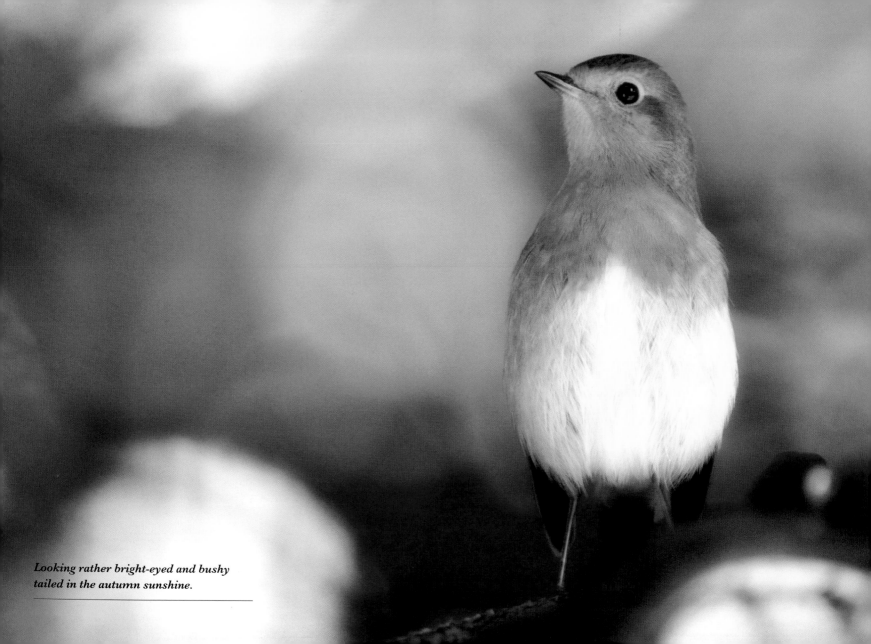

Looking rather bright-eyed and bushy tailed in the autumn sunshine.

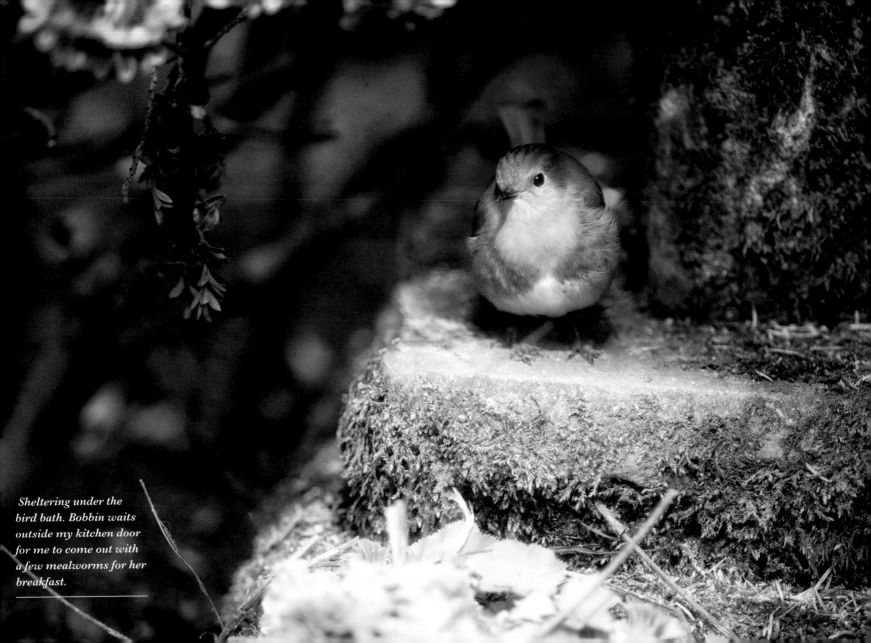

Sheltering under the bird bath. Bobbin waits outside my kitchen door for me to come out with a few mealworms for her breakfast.

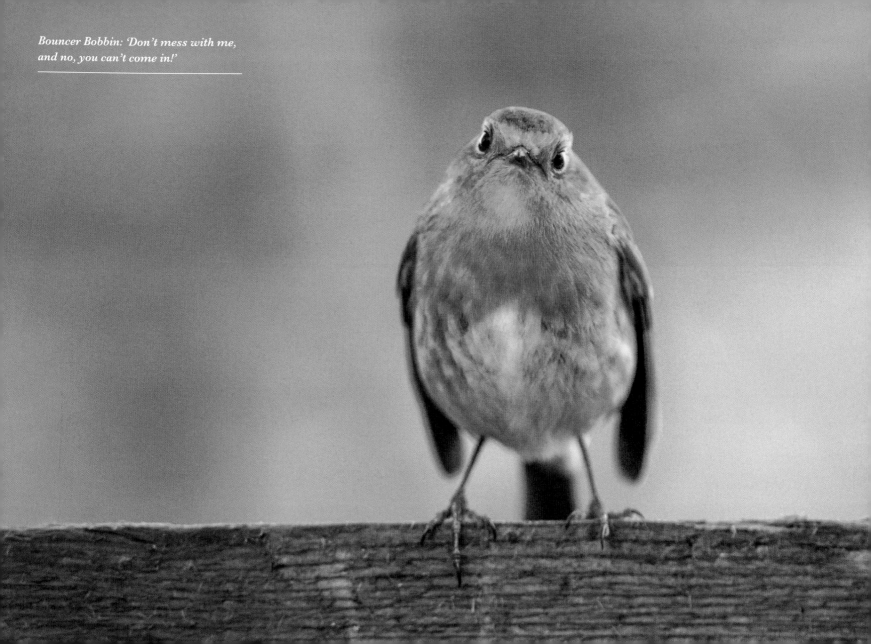

Bouncer Bobbin: 'Don't mess with me, and no, you can't come in!'

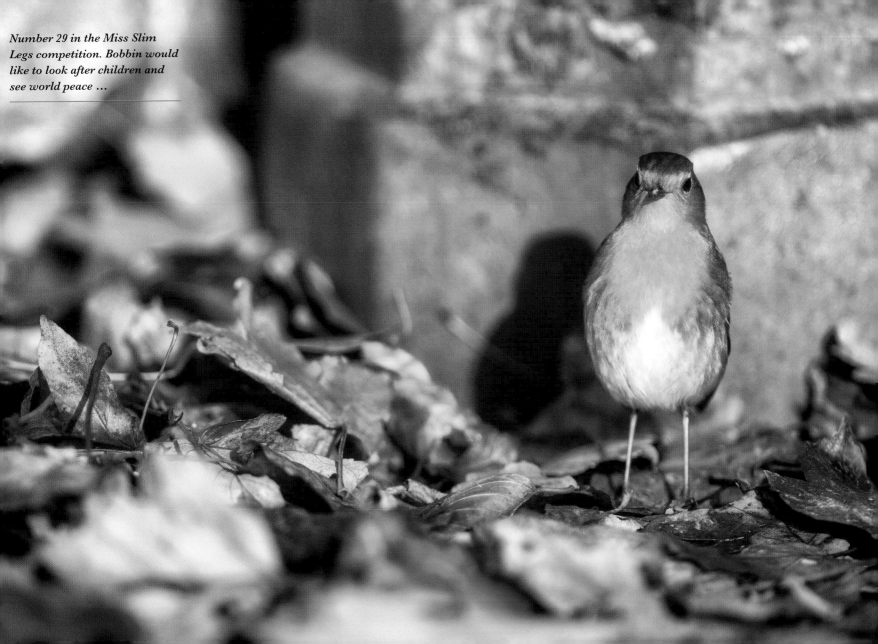

Number 29 in the Miss Slim Legs competition. Bobbin would like to look after children and see world peace …

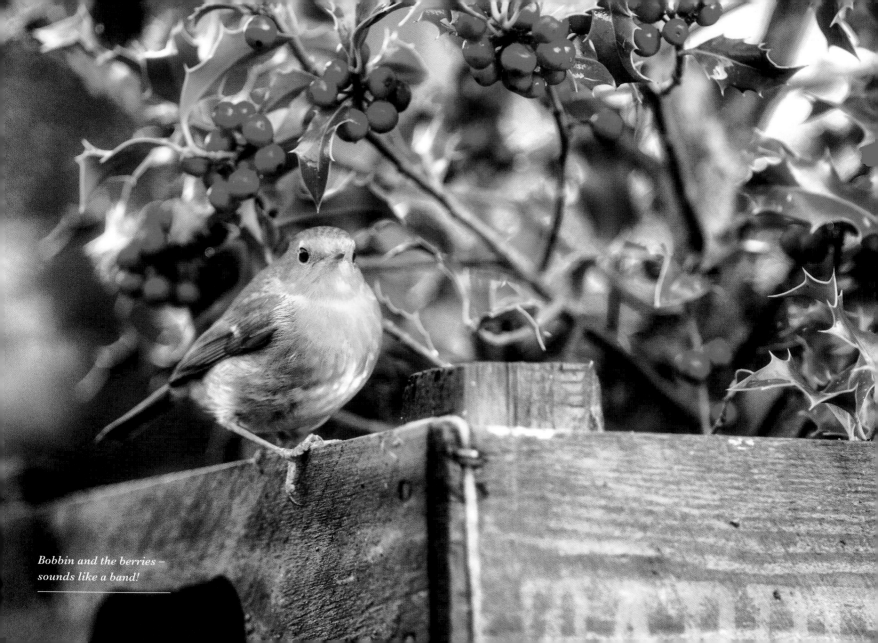

Bobbin and the berries – sounds like a band!

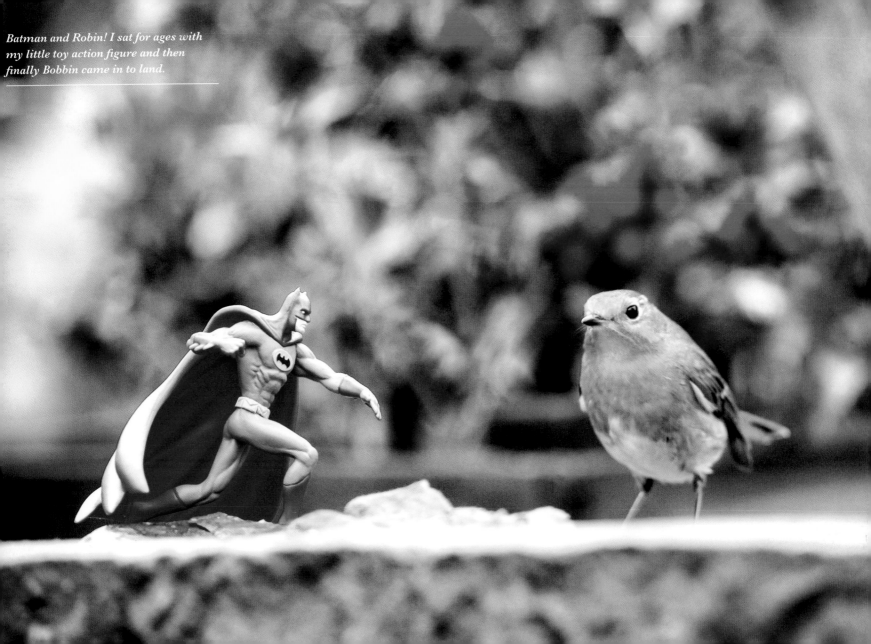

Batman and Robin! I sat for ages with my little toy action figure and then finally Bobbin came in to land.

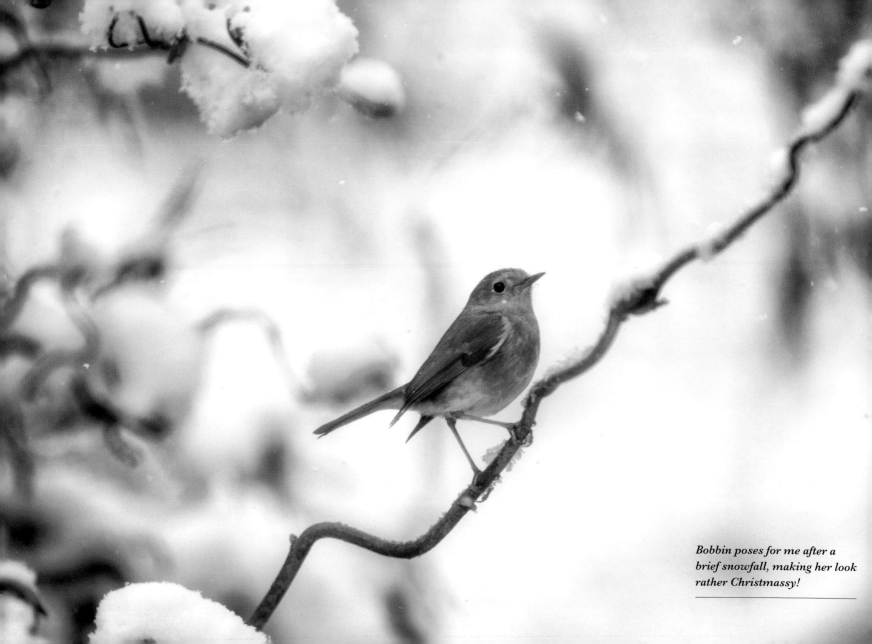

Bobbin poses for me after a brief snowfall, making her look rather Christmassy!

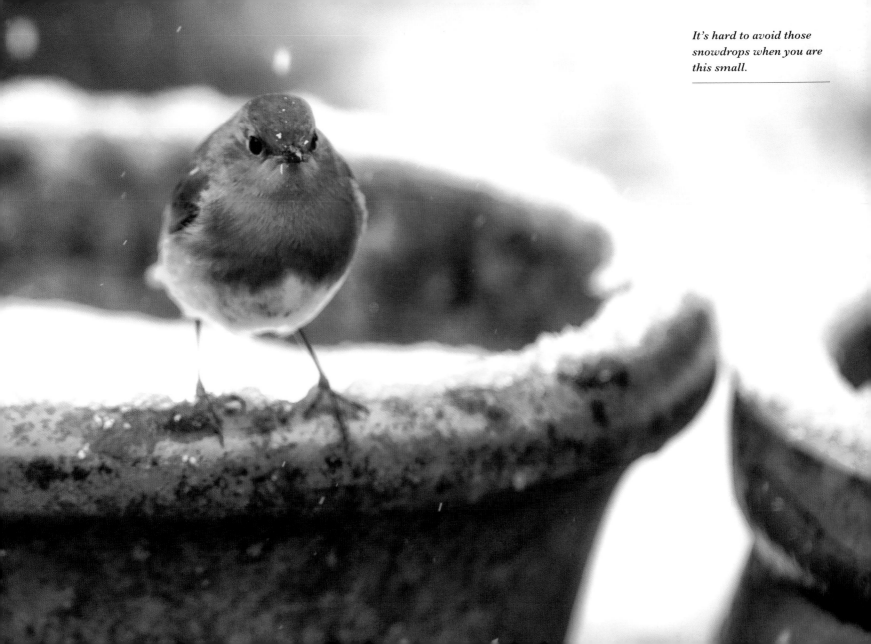

It's hard to avoid those snowdrops when you are this small.

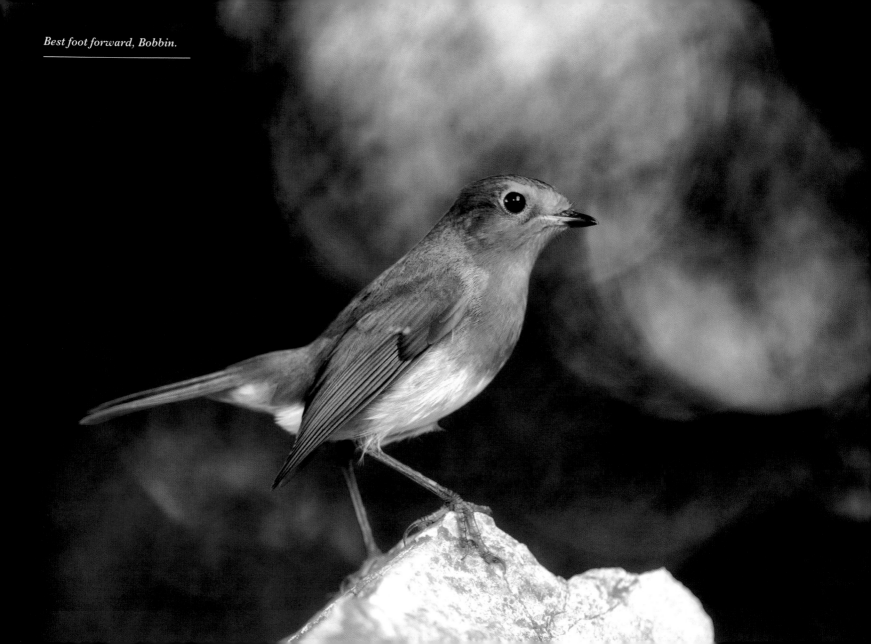

Best foot forward, Bobbin.

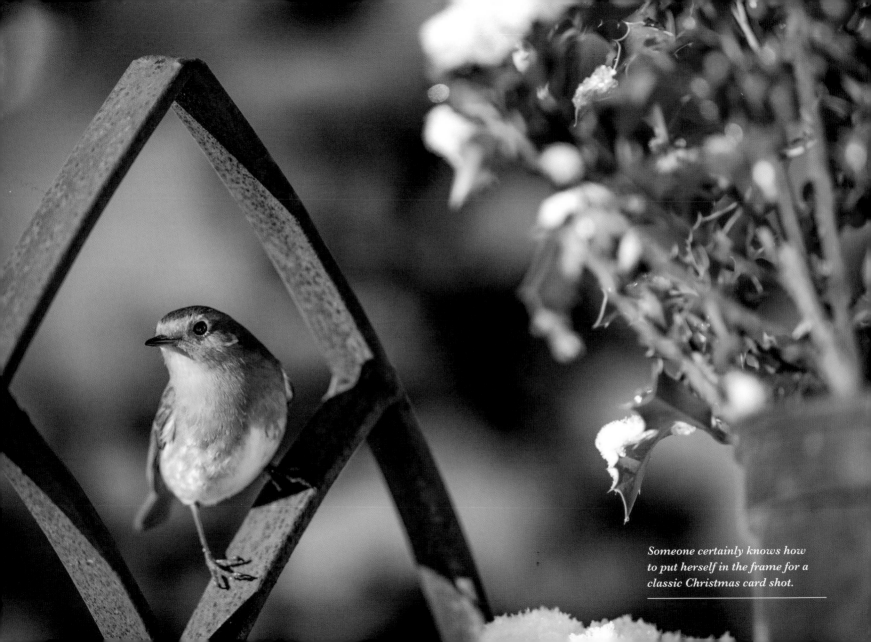

Someone certainly knows how to put herself in the frame for a classic Christmas card shot.

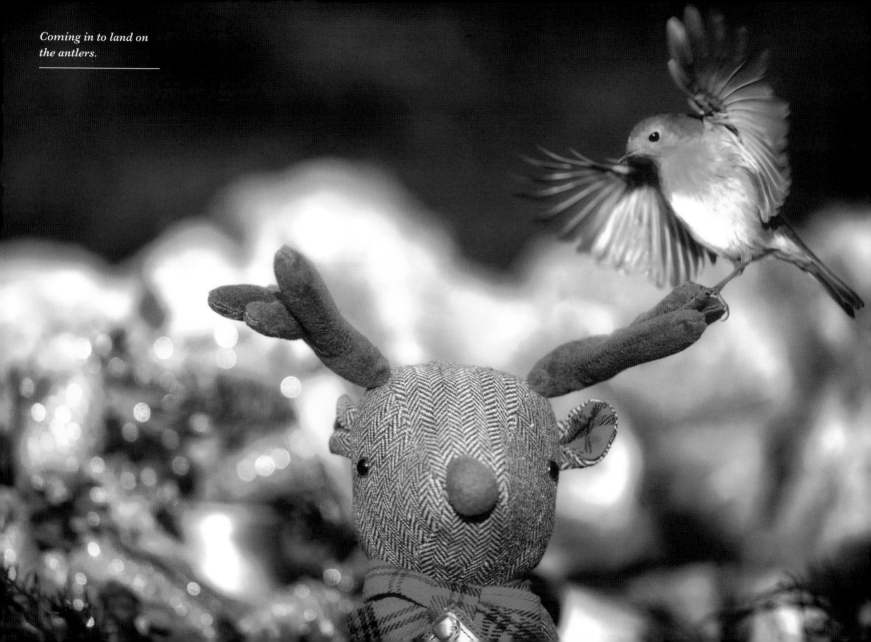

Coming in to land on the antlers.

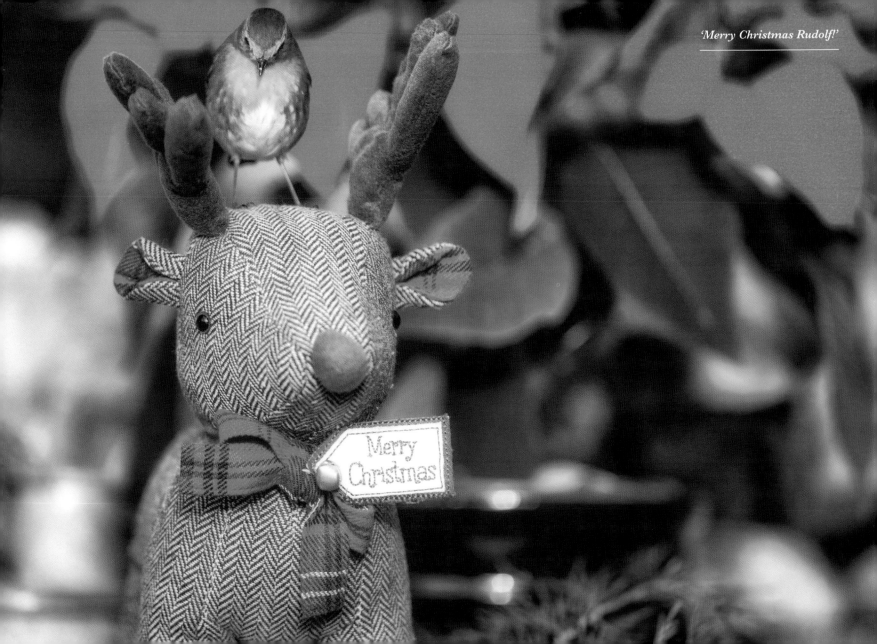

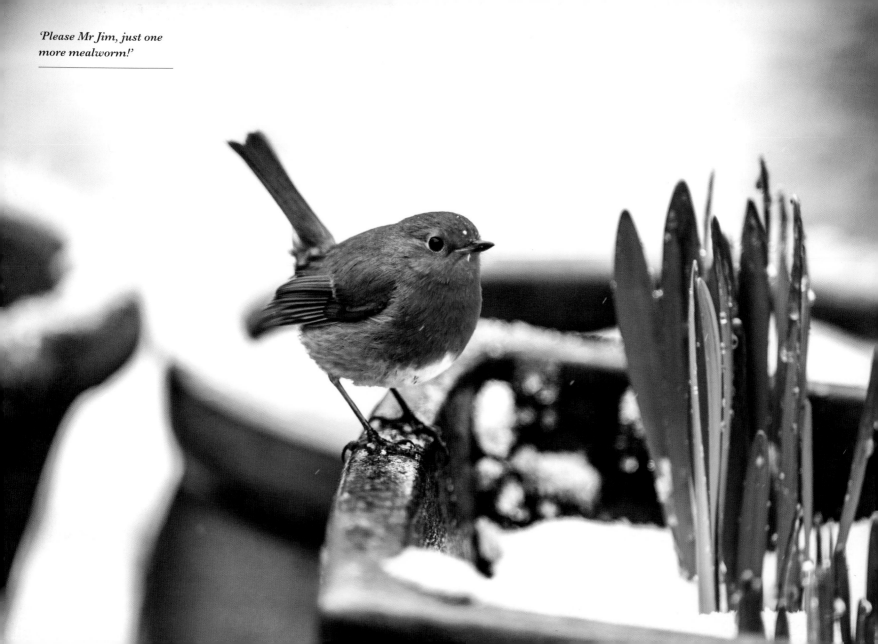

'Please Mr Jim, just one more mealworm!'

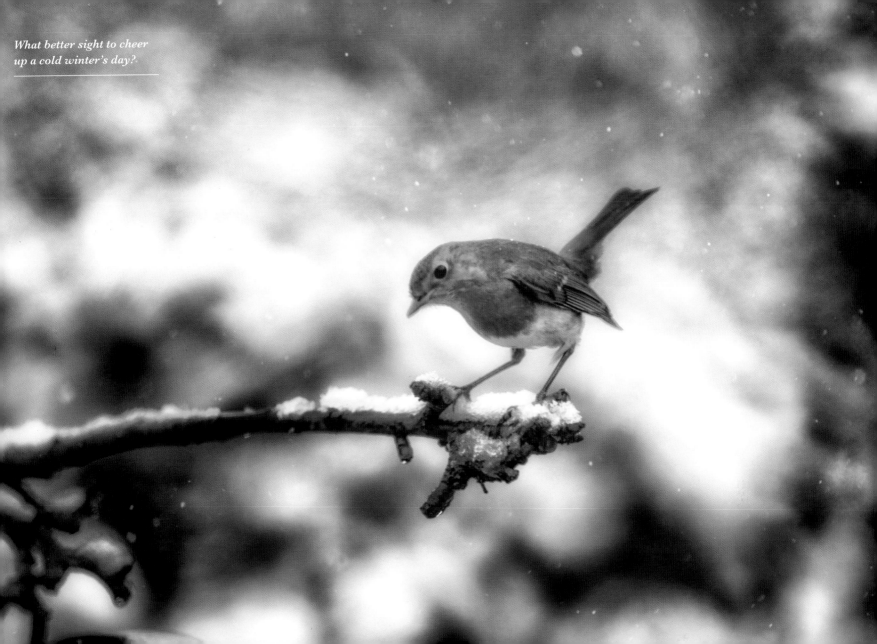

What better sight to cheer up a cold winter's day?

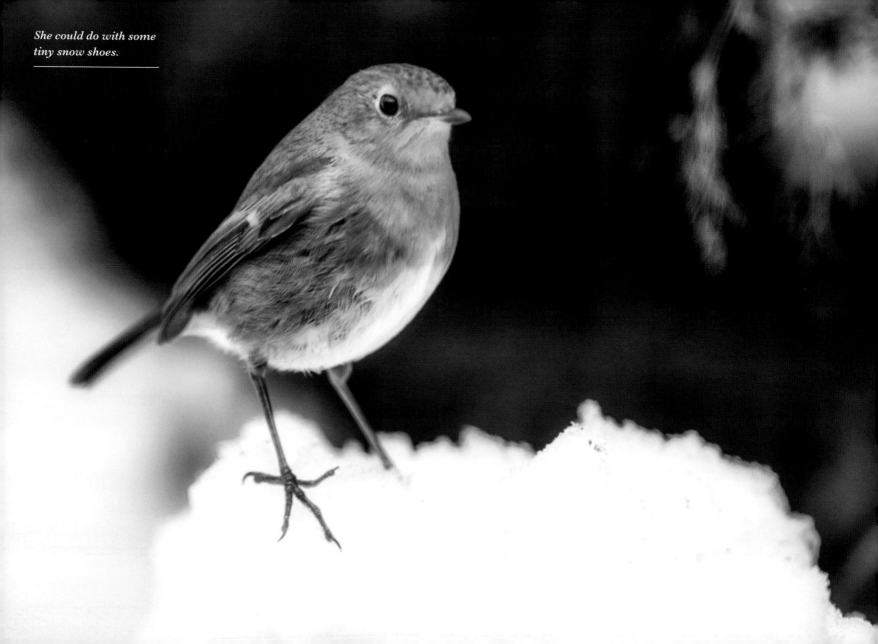

*She could do with some
tiny snow shoes.*

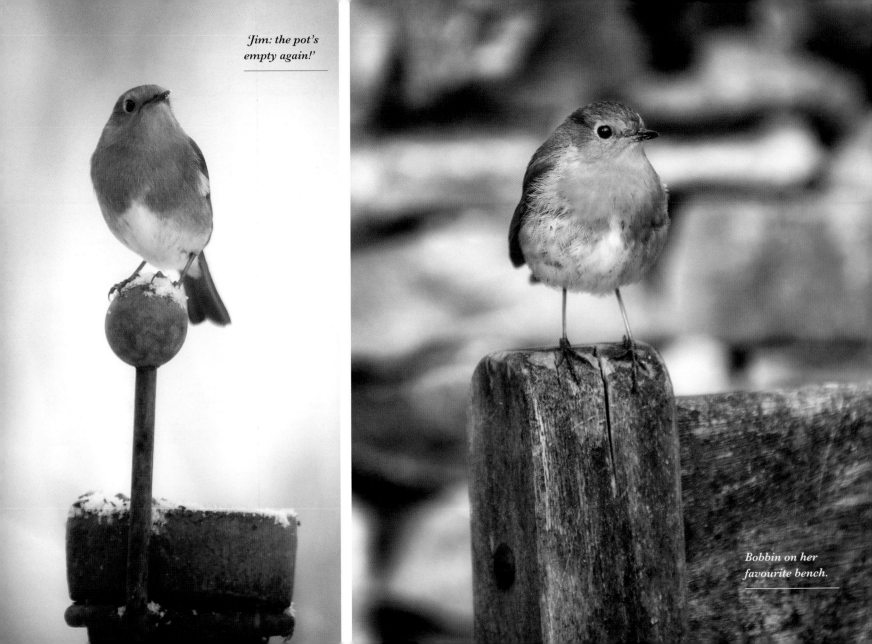

Jim: the pot's empty again!'

Bobbin on her favourite bench.

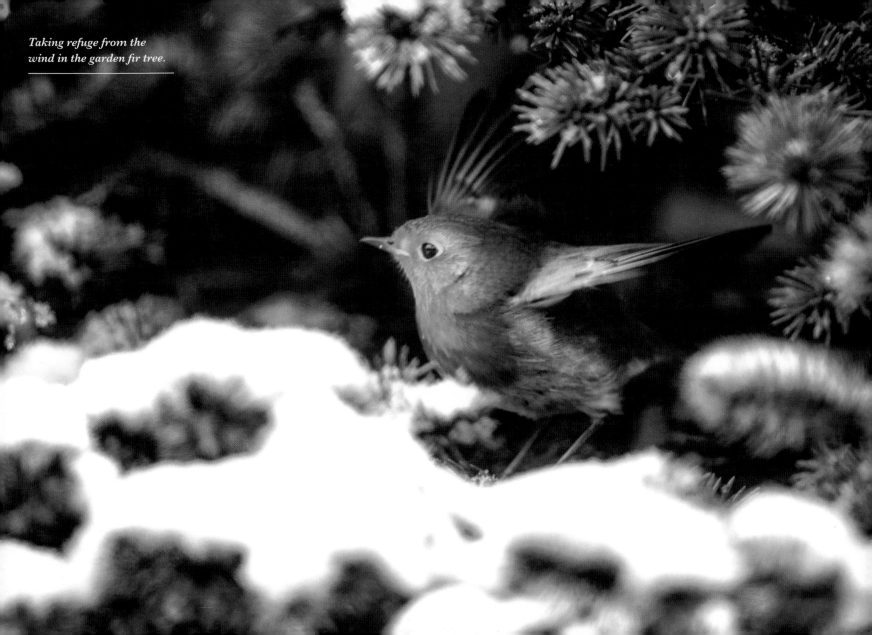

Taking refuge from the wind in the garden fir tree.

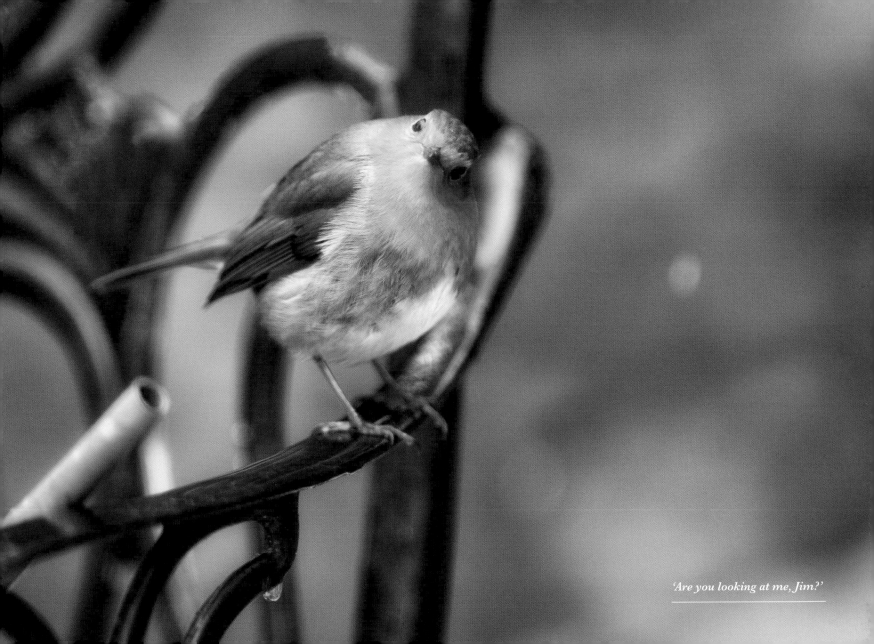

'Are you looking at me, Jim?'

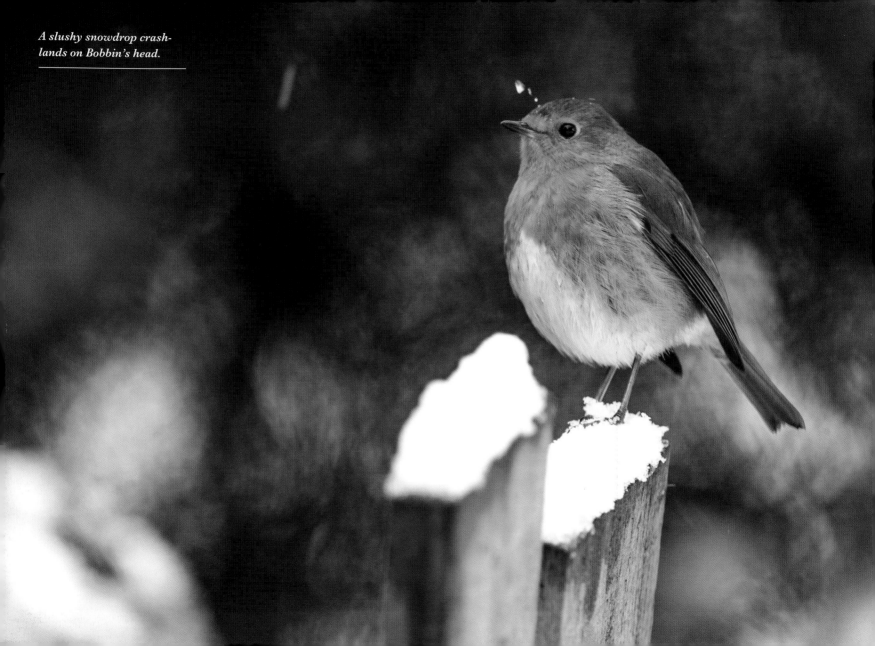

A slushy snowdrop crash-lands on Bobbin's head.

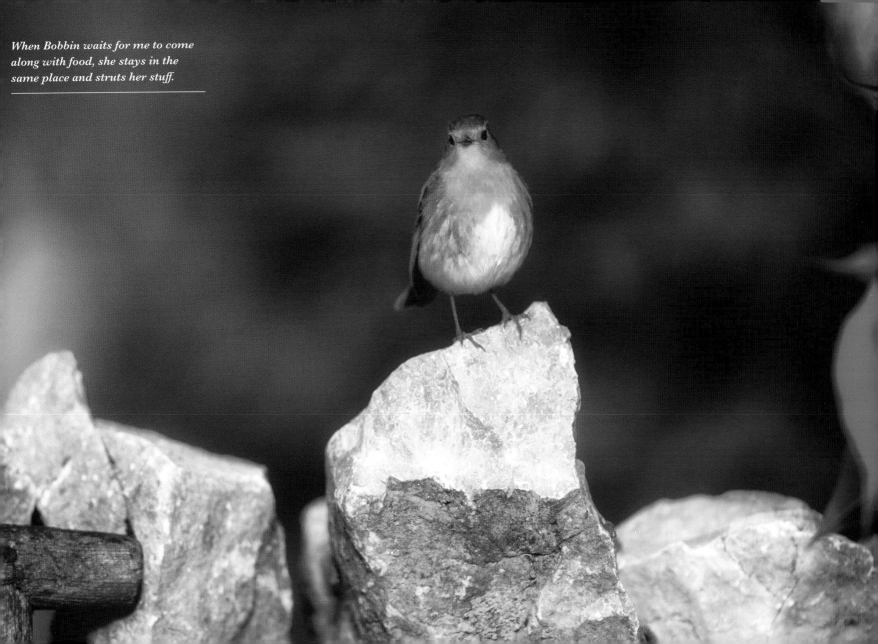

When Bobbin waits for me to come along with food, she stays in the same place and struts her stuff.

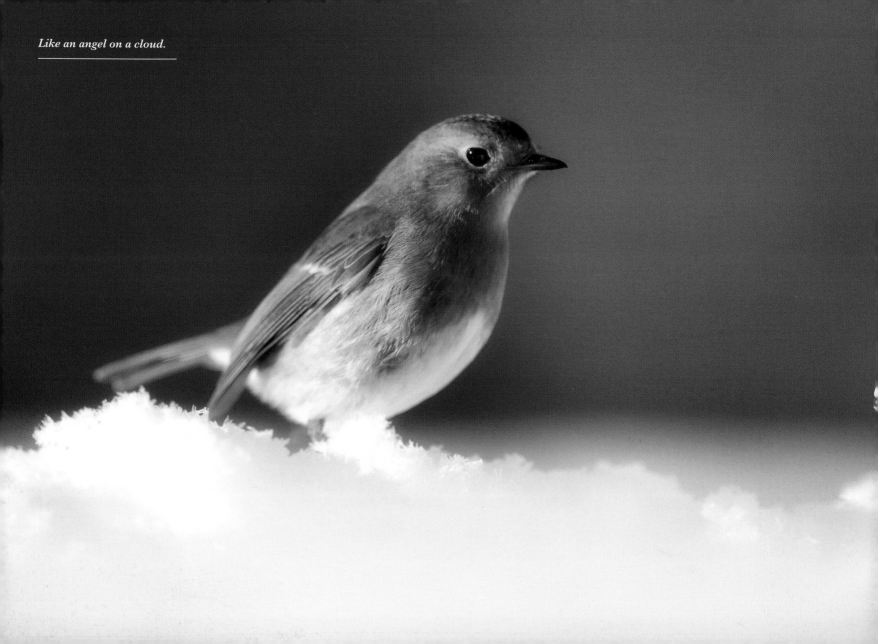

Like an angel on a cloud.

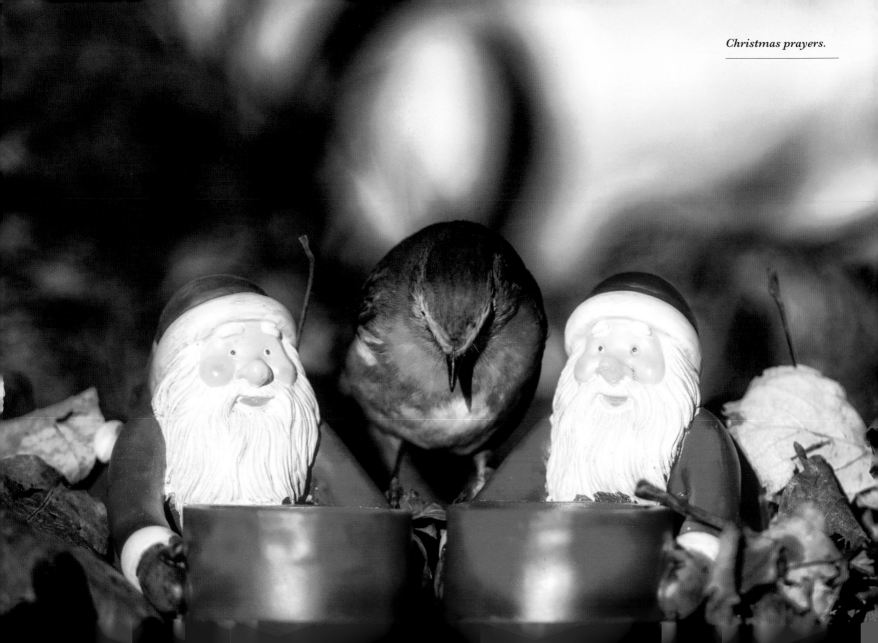

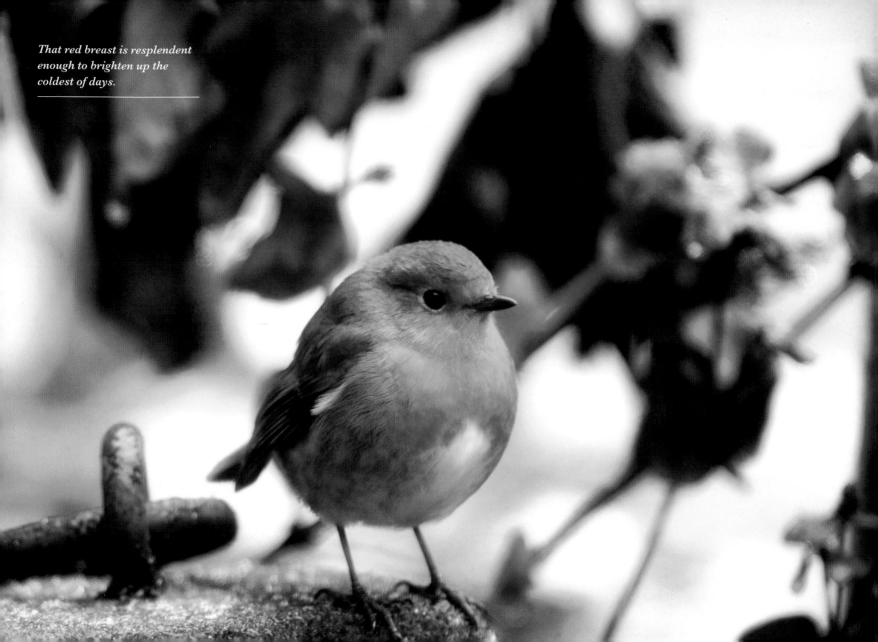

That red breast is resplendent enough to brighten up the coldest of days.

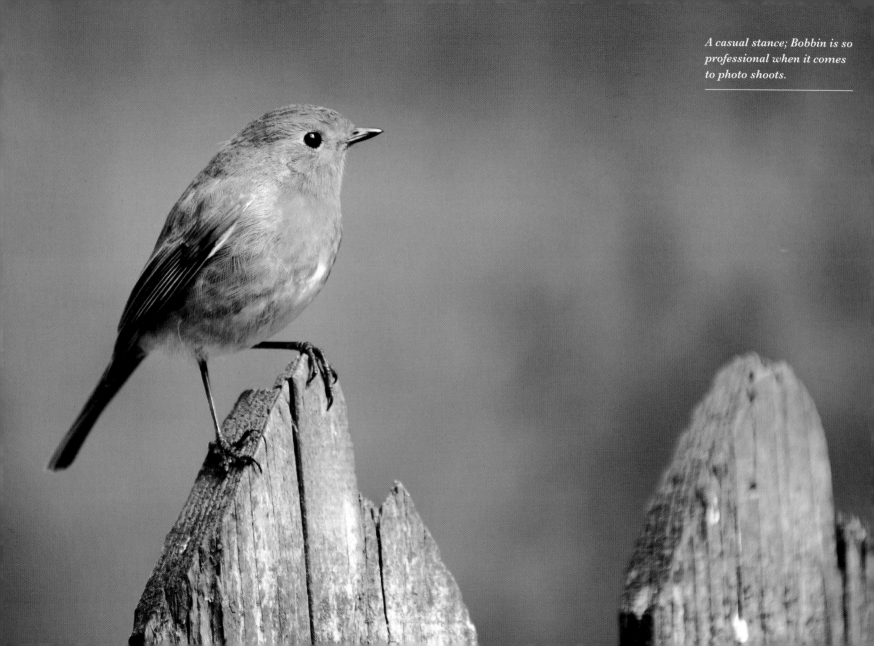

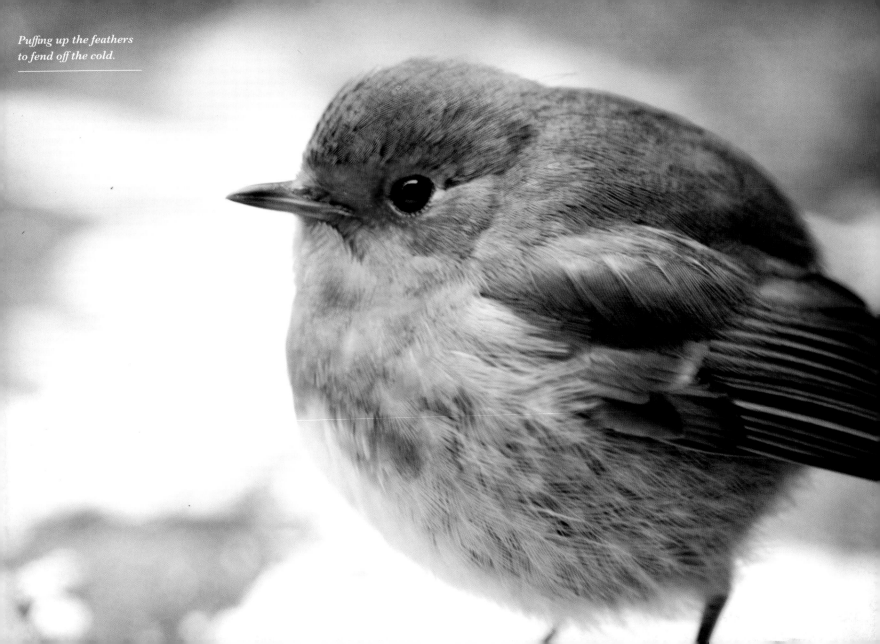

*Puffing up the feathers
to fend off the cold.*

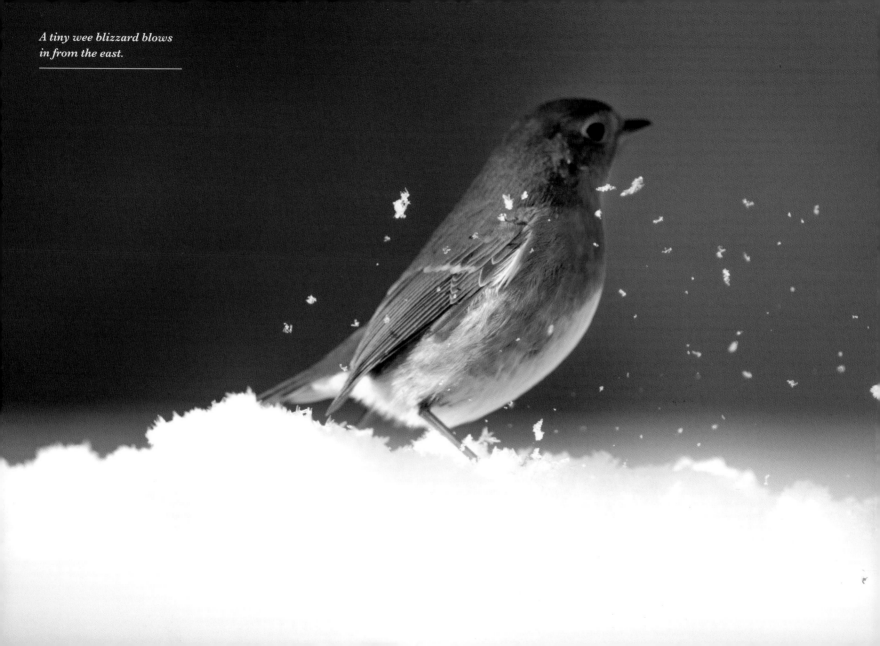

A tiny wee blizzard blows in from the east.

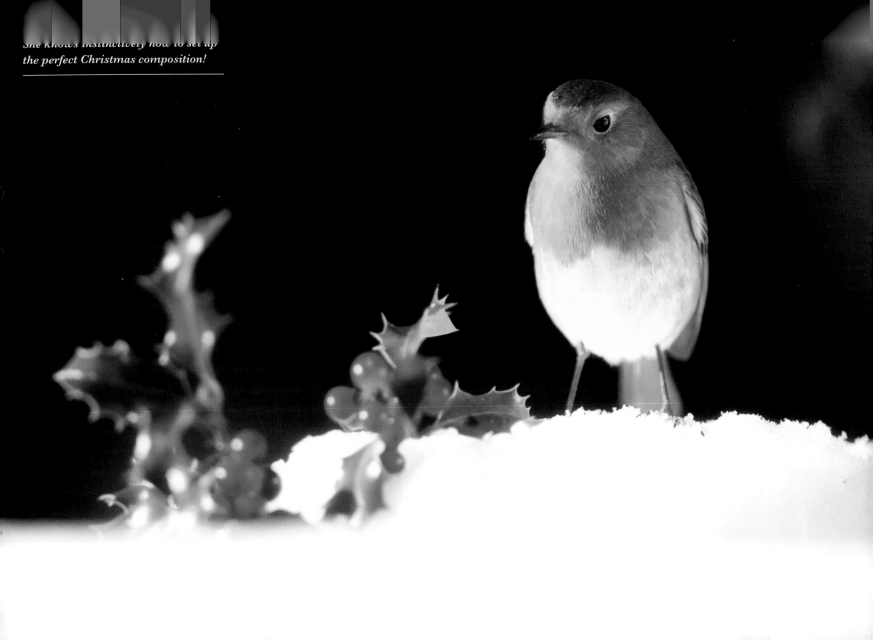

Visit Villager Jim's website shop for a range of gifts and homeware featuring his wildlife photographs

- Greetings Cards
- Canvas Prints
- Calendars
- Books
- Jigsaw Puzzles

- Cushions
- Stationery
- Tablet Covers
- Home & Garden ware
- Luggage

- Mugs
- Phone Covers
- Clocks
- Candles
- Calenders

and much more

www.villagerjimsshop.com